Oils

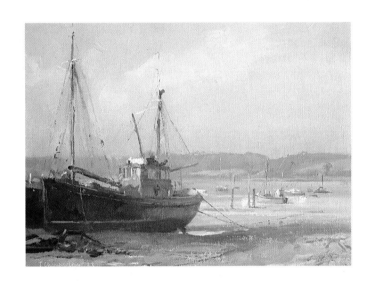

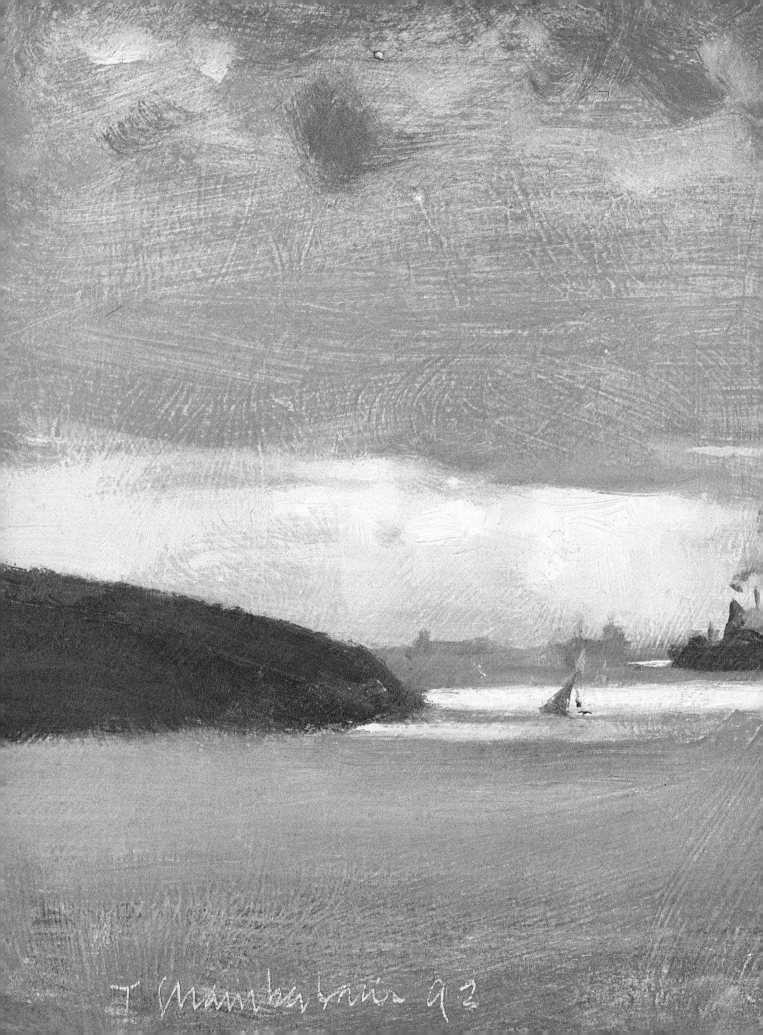

Ron Ranson's PAINTING SCHOOL

Oils

TREVOR CHAMBERLAIN

ANAYA PUBLISHERS LTD.
LONDON

First published in Great Britain in 1993 by
Anaya Publishers Ltd., Strode House,
44-50 Osnaburgh Street, London NW1 3ND.

Text Helen Douglas-Cooper
Editor Alison Leach
Art Director Jane Forster
Photography Shona Wood

British Library Cataloguing in Publication Data

Ranson, Ron
 Oils - (Ron Ranson's Painting
 School Series)
 I. Title II. Series
 751.45

 ISBN 1-85470-052-9

Typeset in Plantin in Great Britain by
Bookworm Typesetting, Manchester

Colour reproduction by J. Film Process, Bangkok
Printed and bound in Italy by OFSA Spa.

Front cover: June Evening, Lyme Regis.
Title page: Shipping off Falmouth.

Contents

Foreword

Apart from the fact that he has won countless awards, the most enviable thing about Trevor Chamberlain is that he paints as every painter would like to! Completely self-taught, it wasn't until 1964 that he abandoned his work as an architectural draughtsman to become a full-time artist.

There is nothing slick or showy about Trevor's work, but his technique is totally sound and he has gained enormous respect within the profession.

Having worked with Trevor on three previous books, he was, naturally, my first choice when this opportunity arose. Quite simply, I could think of no-one better suited to being the author. I was very lucky to catch him just as he was completing an exciting collection of paintings for a one-man exhibition as this meant that most of the pictures could be photographed for this book.

Trevor's awards and achievements are numerous and impressive, and include membership of the Royal Institute of Oil Painters, the Royal Society of Marine Artists and the prestigious Wapping Group.

Ron Ranson

ON THE DORDOGNE, FRANCE (17 x 25 cm/7 x 10 in)
In this simple scene, the distinctive, flat-bottomed boats formed a strong feature. It was painted from a high viewpoint, cutting out the sky and the far bank, and homing in on the main area of interest. The contrast between sharp and muted light gives the picture its distinct atmosphere.

Introduction

Working on site from observation is one of the most rewarding approaches to painting. It is also one of the most challenging because you are dealing with fleeting lighting effects and moving subjects. However, it is not as tricky as it seems at first if you follow a method of working specifically developed for this kind of painting.

It is not necessary to hunt out picturesque subjects in order to produce an interesting painting. Some of the most effective paintings are of the most simple, everyday scenes and activities. The most important point is to begin painting as quickly as possible. If you don't have a specific subject in mind, settle on something quickly. Do not wander or drive around for hours thinking that there might be something better round the next corner.

In time, you will get to know the places and subjects that interest you most. Visit them at different times of day and in varying weather conditions, and look at them from different viewpoints. Decide which are best suited to a particular subject, or make a series of paintings in different conditions. Once you have chosen your subject, think about what aspect appeals to you most, and keep it in mind constantly while you are painting, as that is what you need to emphasize.

When you are visiting somewhere for the first time, maybe on holiday, it is worth spending a little while looking around and getting the feel of the place. You could make a few quick, rough sketches of possible subjects as you go.

SUMMER, BLOMFIELD ROAD (17 x 25 cm/7 x 10 in)
The appeal of this subject lay in the elegant houses against the dark trees, the effect of the light as it bounced off the wall of the house, the light on the road, and the overall warm feel.

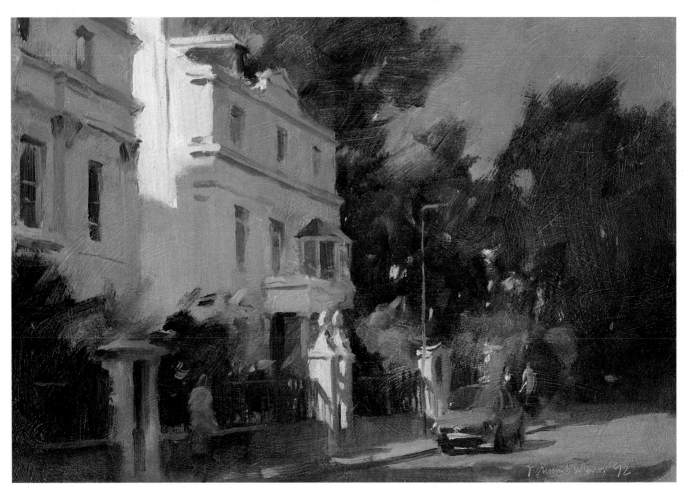

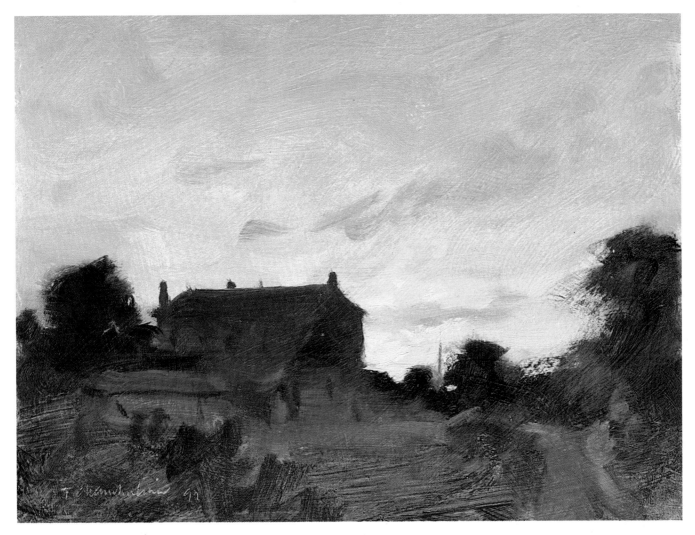

EVENING, LE MANOIR DE LUSSAC (15 x 20 cm/6 x 8 in)
*This dramatic scene made an immediate impact, and it was
painted on the spot in about 15 minutes, despite the fact that it
was beginning to get dark. A limited palette of white,
cadmium yellow, yellow ochre, burnt sienna, alizarin crimson,
viridian and ultramarine was used. The whole picture was
roughed in very simply, using directional brushmarks to
suggest the different elements, and a lot of the underpainting
has been allowed to show through. Restrained highlights were
added to the roof of the barn and on the road and field.*

*If you happen to come across lighting conditions like this,
you need to seize the moment and start painting immediately
because such an effect does not recur.*

Don't let dull weather put you off painting. The
conditions will be constant, and although you may
have to work a little harder to achieve the tones and
colours, it is possible to produce a harmonious
picture with quite a lot of unexpected colour in it.
Water in particular can enliven a scene on a dull day.

Once you have started painting, try to work
intensively for two to three hours, as this will give a
feeling of liveliness and spontaneity to the work.
Make a few main statements, then step back and
weigh up what you have done. If you feel you have
made a bad start, scrape off the paint and start
again. Every so often, stop painting and look around
you, then come back to the painting, as this will help
you to judge what you have done objectively. Even
at the risk of appearing rude, don't let people
distract you or engage you in conversation.

Although you can learn a lot by studying and
making copies of the work of other artists, do not
closely imitate the work of one painter. Your
paintings should say something about yourself as
well as the subject. The paintings illustrated in this
book, together with the practice sessions, are
intended to point you in the right direction and get
you started. However, it cannot be emphasized
enough that you should go out and find your own
subjects and work directly from them. Look for
subject matter that particularly interests you,
interpret it in your own way, and enjoy yourself.

Don't be discouraged by your first attempts. As
you continue to look, paint, and assess your work,
you will gradually discover ways to get the effects
that you want.

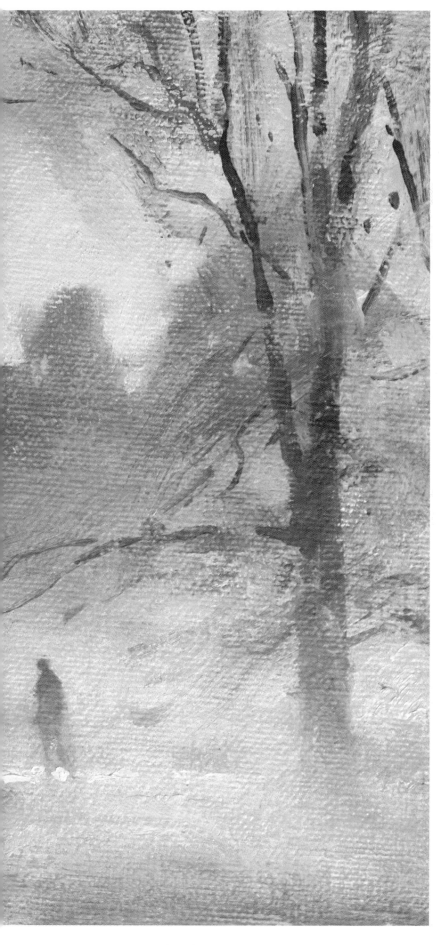

THE BASICS

If you are just starting out, it is worth spending a little time experimenting with your materials before you begin a painting. It really does help to develop a feel for the paint, and to try out the effects you can get using different types of brush. Tone, composition and colour form the basis of any kind of painting, and an understanding of these will also help you to organize your paintings and achieve the results you want much more easily.

AFTERGLOW AND RIVER MIST
(17 x 25 cm/7 x 10 in)
A very effective painting can be made of a scene consisting of simple shapes and a limited range of colours. The sun was beginning to go down, and light was shining on the mist rising off the water. The branches of the main tree were very simply stated against the mist. The light on the water attracts the eye to the figure, which is in silhouette.

Materials and Equipment

If you are intending to paint out of doors, you should reduce your equipment to the minimum, and organize it so that it is as light and easy to carry as possible. You need a sketching easel, a palette and a box for your painting materials. Keep a supply of canvases or prepared boards in two or three sizes. Store your equipment in an easily accessible place and ready for the next trip so that you can grab it and go whenever you like.

EQUIPMENT

Various types of sketching easel are available for outdoor work; go for the sturdiest that you can find, because it will have to stand up to regular use and some punishment from the weather. The most common ones are made of wood, but metal ones are also available.

Easels with a box incorporated in them provide a place to put all your equipment at the right height, but they are expensive and quite heavy to carry. It is also possible to buy easels with a seat incorporated. However, it is much better to stand up to paint, unless you find this uncomfortable, so that you can keep stepping back from your work to view it. You also have much greater freedom of movement for making fluent brush strokes if you are standing.

Your palette should be large, light and well balanced so that it rests comfortably on your arm. Small palettes are not recommended because you need plenty of space for mixing paints. A natural or neutral colour palette is better than a white one. If you mix paint on a white palette, the colours will look much darker in tone than they do when you transfer them onto a canvas that already has colour on it, and this may mislead you into mixing up all your colours too light.

Either genuine turpentine or white spirits can be used to thin the paint in the initial underpainting, and for cleaning brushes. Some people mix a little refined linseed oil with the paint for the top layers, but this slows down the drying time, which can be a problem when you are working quickly and wanting to complete the painting in one session.

A clear, quick-drying gel, which you mix with the paint as you apply it, is very useful as it speeds up the drying time of the paint. It is available in tubes,

and is described as either quick-drying glazing medium or thixotropic oil-painting medium.

Various sizes of paint boxes are available, with compartments for brushes, paint, small bottles of solvent and all the other bits and pieces that you need, and lids that are deep enough to take a board or canvas, or sometimes both, for ease of carrying.

The following checklist should provide you with

A large palette provides plenty of space for mixing colours. The brushes are, from left to right: acrylix size 2, sable rigger, long flats sizes 2, 4, 6 and 10.

everything you need for a painting expedition.

A small bottle of turps or white spirits – remember to top this up after each session so that it is ready for the next one.

A double dipper – this consists of two small, shallow metal containers for holding turps or white spirits, and slides onto the palette. Use one container for the turps or white spirits that you use to thin the paint, and the other for cleaning brushes as you are painting.

One or two rags – for wiping back areas of paint on the canvas, and for cleaning brushes.

Sticks of charcoal and a pencil – for marking the main elements of the picture on the canvas, and for making quick sketches.

A viewfinder – this is helpful for selecting and finalizing the composition; see page 42. It can be made by cutting a rectangle measuring about 7.5 x 5 cm/3 x 2 in, or in proportion to the size of canvas you use, out of the middle of a piece of card.

Brushes – see page 16.
Palette knife – see page 17.
Paint – see pages 46-48.
A tube of gel.

It is a good idea to take a sketchbook around with you, even if it is only a small one. You never know when you'll see something you want to draw, or have 10 minutes to spare when you could sketch something quickly.

COPING WITH THE ELEMENTS

When you are standing or sitting out of doors for two to three hours, you can quickly begin to feel cold, even on a mild day, and it is important to wrap up well. You need a windproof top layer, but make sure that it does not restrict your movement. Wear warm boots or shoes and thick socks, and a hat with a peak to shield your eyes from glare. Shooting mittens are good for keeping your hands warm while painting. They are leather-backed, fleece-lined, and have open palms, with two loops that go around the thumb and middle finger, giving you maximum freedom of movement in your hands. A hand-warmer is also useful on cold days.

WHAT TO PAINT ON

Oil paint can be used on a variety of supports: canvas (such as linen or cotton) on stretchers, canvas or muslin applied to board, plain or textured hardboard, plywood or strong cardboard. Stretched canvas is preferred by many painters because it has some give in it, whereas boards tend to be very hard. Canvases and canvas boards come in different textures and grades, and you need to try them out to find one that suits you. If you are buying ready-prepared stretched canvases and canvas boards, check that they have been primed for use with oil paints with either oil-based or acrylic primer.

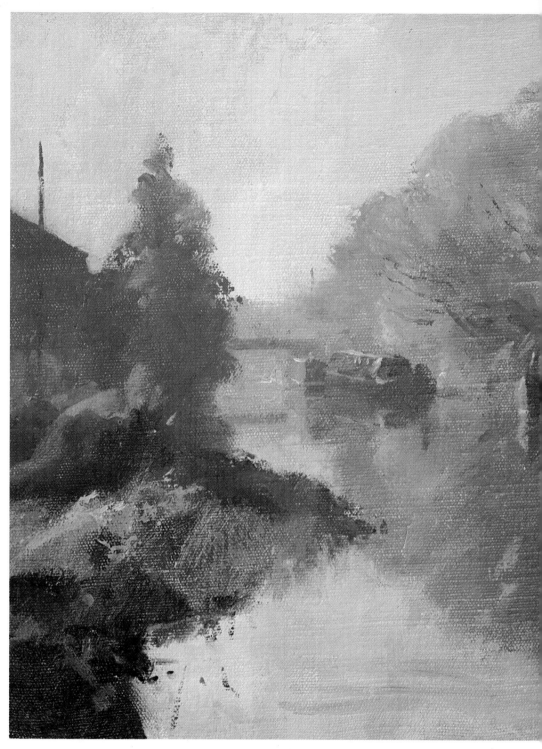

OCTOBER LIGHT, RIVER LEA
(25 x 35 cm/10 x 14 in)
The initial roughing in on the sky was done with a large brush, and then blended a little with a finger.

The foliage and trees on the bank behind the boats were roughed in with a size 10 brush, and the tops of the trees were softened slightly with a finger. A palette knife was used to scumble in the foliage of the further trees, using a warm orange-grey. The trunks and branches were put in with a sable brush over the initial brushwork at a late stage. This gave the underpainting a chance to dry so that it was not picked up by the fine brushwork.

Warm underpainting is showing through on the right-hand side of the boat, and cool blue is showing through on the cabin. The light side of the boat was put in with a palette knife, and the windows in the cabin were made with small vertical brushmarks.

On the left-hand riverbank, green underpainting shows through.

The reflections of the trees in the water were softened slightly with a finger to echo the softening in the foliage and sky.

You can prepare pieces of hardboard and cardboard yourself. Use the smooth side of hardboard and rub it down with glass paper. Both types of board should be primed with three coats of acrylic primer, and you can add texture to the surface by mixing some acrylic texture paste into the third coat of primer. It is worth having a supply of boards that you have prepared yourself, and which you don't feel are too precious, to experiment and practise on, and for doing quick colour sketches of things that interest you.

To begin with, 25 x 17 cm/10 x 7 in is a good size to experiment on. For doing a painting on the spot, 35 x 25 cm/14 x 10 in is suitable; anything larger will be difficult to complete in the time available. If you are used to working on a large format in the studio, you should try to change your approach when painting out of doors, because you need to think smaller in order to achieve what you set out to do in a limited time.

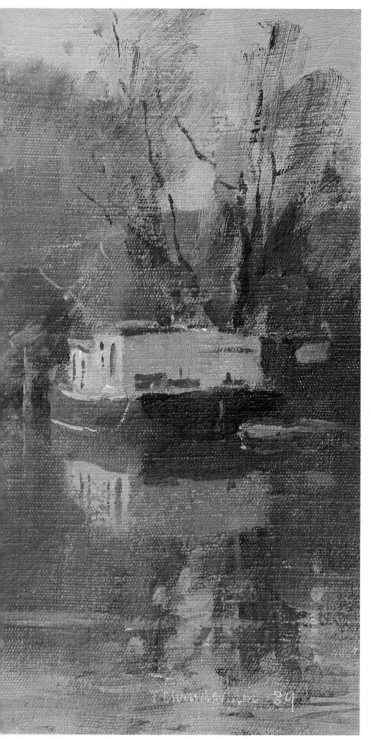

THE POCHADE BOX

This incorporates a box that holds paints and other equipment with a slide-out palette and a lid that can hold up to four small boards spaced slightly apart. A dipper can be positioned against the side of the box to keep the palette in place when it is pulled out. The lid acts as an easel, holding the board on which you are painting. There is a thumb-hole in the base of the box so that it can be held like a palette. If you don't want to stand and hold the box, you can sit and rest it on your lap or on a convenient wall, or use it sitting in the car.

Pochade boxes are made in a range of sizes, but as their advantage lies in the fact that you can hold them while painting, thus making you less conspicuous than when using an easel, it is better to get one of the smaller sizes. In addition, if you were using a larger-sized canvas in a pochade box, you would be working too close to it. Even with a small painting, you need to get up and step back from it from time to time.

A pochade box carries everything you need - palette knife, paint, a small bottle of turps or white spirits, a dipper, pencil, brushes, gel and a rag. Keep it easily accessible, ready for use. You can be quite inconspicuous using it, and the small format is good for doing something quickly.

BRUSHES

For oil painting you should use hog-hair brushes,
which are available in various shapes and sizes. You
will need a large brush for roughing in the
underpainting. The best type is a long-bristled flat.
A size 10 is about right as you need to work quickly
and broadly. In addition, you will need long flats in
sizes 8, 6, 4 and 2, and a sable rigger, size 3 or 4,
for linear marks. A soft acrylix short flat, size 2, is
also useful; it can be used flat, or on its side for
delicate brushwork.

Short flats (brights), rounds and long-bristled
brushes with rounded ends (filberts) are also
available. Try them too to see if you prefer the marks
they make to those of the brushes suggested above.

The bigger brushes are best for painting the
broader passages, while the smaller brushes are
more suitable for finer work and detail. The rigger
should be used sparingly, for suggestions of fine
lines such as boat rigging, fences or branches, but
do not paint with it too much because it creates
rather graphic effects. Any lines should be broken –
known as lost-and-found – because if you merely
suggest a line, the eye will link it up, making it more
interesting to look at than a continuous line.

Brushes made of nylon and nylon/sable mixtures

A thinned layer of paint has been applied with a large (size 10), hog-hair brush using random strokes. The brushstrokes are very evident. This is the type of brushwork to use for roughing in.

Marks have been made with a medium-sized (size 6) long flat. In the left-hand sample, the brush has been used to make short, horizontal strokes. In the right-hand sample, the brush has been drawn down in one continuous stroke.

The paint has been applied using the side of a size 6 brush to create a thin, vertical mark.

Stippling should be used sparingly in areas where you want small amounts of the colour underneath to show through and blend with the colour you are applying.

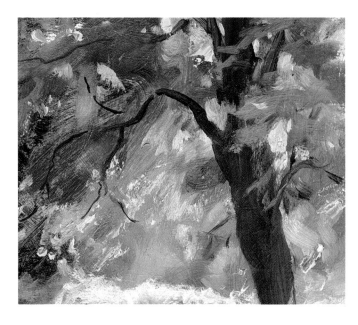

Detail from COW PARSLEY, GOLDINGS (page 86)
The area between the branches of the tree and the top of the cow parsley are stippled to create the effect of dappled light.

Detail from OCTOBER LIGHT, RIVER LEA (page 14)
Very loose brushmarks were used for the trees. These would not make any sense on their own, but as soon as the branches are added, the marks read correctly. The branches were put in with uneven, broken lines.

don't stand up well to constant use. They splay open and lose their points. The harder, hog-hair brushes create brush marks that remain visible, adding interest to the surface of the painting, whereas the marks made by softer brushes smooth out.

When painting broad areas, hold the brush near the end of the handle so that you can make big sweeps. As you come down to more detailed statements, hold the brush near the ferrule so that you have more control for making small, specific marks.

PALETTE KNIVES

Palette knives are better than painting knives for applying and mixing paint, as they are stronger and less fiddly. Choose a 10 cm/4 in, strong knife with a cranked handle. It should be flexible along the blade and at the tip. It is important that the knife is cranked, so that you do not accidentally brush your knuckles against the canvas when you are putting on the paint.

The palette knife can be used to apply broad areas of paint, or along its edge to create thin, straight linear marks. Whole paintings can be done with the knife – see *Obsolete Signal-box, Kings Cross* (page 98) and *Welsh Cockle-gatherers* (page 56). These show that

The paint has been scumbled on, meaning it has been skipped across the surface of the canvas to create a broken layer of colour and allow the colour underneath to show through. Use a flat brush and make the strokes in the appropriate direction.

A solid area of colour has been applied with obvious directional brushstrokes. These can be used to suggest structure, surface detail and the direction of growth.

The paint has been applied with random brushstrokes. These can be used to break up flat, uninteresting areas to give texture and surface interest, or to blend colours roughly.

Linear marks have been made with a sable rigger. The same kind of marks can be made with the side of a short acrylix brush. Use these where you want fine lines, such as for branches, boat rigging or fences.

a knife can, with practice, be used to create subtle effects. You need to become quite accomplished at this if you intend to use a knife extensively, because the effect can be hard and mannered.

In *Edge of a Sandbank* (page 72), the knife has been used to apply small flicks of paint that instantly read as figures.

EDGES

To create a sharp edge between areas of different colours, state one colour area, then state the next colour beside it, working in the same direction. If you lay the second colour down with strokes at an

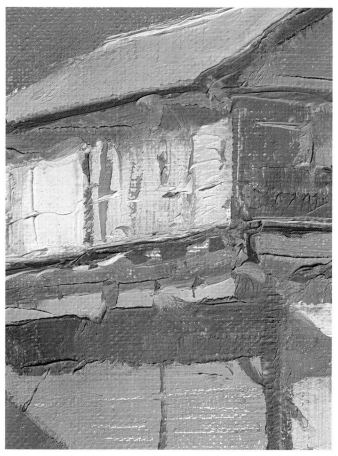

Detail from OBSOLETE SIGNAL-BOX, KINGS CROSS (page 98)
This whole painting was done with a palette knife and is a good example of the way in which, with practice, a knife can be used to create detailed and delicate effects.

On the roof, the paint was put on using the knife flat, and then scraped off again. The light along the ridge of the roof was done using the edge of the knife.

On the light side of the box, the paint was applied quite thickly, and was then worked into with the knife. In places, detail has been indicated by using the side of the knife to cut right into the paint, rather than by painting it in. On the lower part of the box, the knife has been used to scratch back to the canvas in order to suggest texture.

The paint has been smoothed on with the knife, and then partially scraped off, which allows the colour underneath to show through. This technique can be used for roofs and buildings, and in skies and background foliage with a little blending.

The paint has been applied with a short, sideways movement of the knife, creating a distinct edge down one side.

The paint has been applied with a downward stroke. This is useful for painting tree trunks, gateposts and so on.

Very fine lines can be created using the edge of the knife, which should be loaded with paint, placed on the canvas and lifted off again. Do not drag the knife downwards.

Fine curved lines can be made by pulling the top of the knife across the canvas.

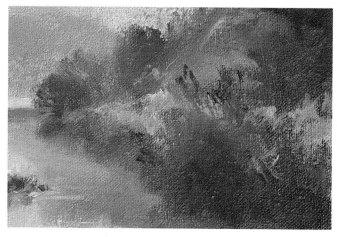

Detail from DAWN FROST, HERTFORD (page 55)
Right, a palette knife was used over the underpainting to suggest the foliage, with some directional brushmarks to show the direction of growth of the bushes. A finger was used to create the frosty effect on the bushes and to blend the reflections in the water.

The area of shadow between the two posts, below right, was scumbled on with a knife, using a dark bluish colour over lighter paint. This created a muddy shadow area that is picking up a little blue light from the sky. A combination of underpainting and brushwork has been used in the foreground. The background has been indicated very simply.

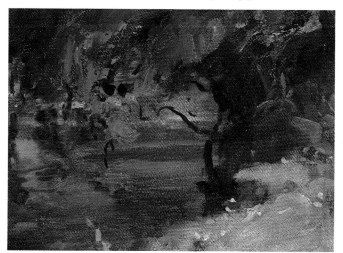

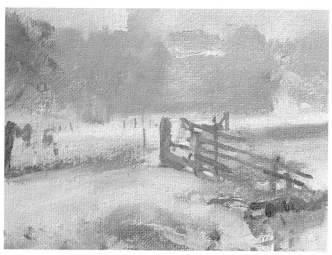

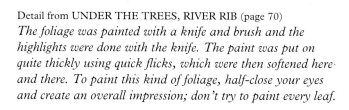

Detail from UNDER THE TREES, RIVER RIB (page 70)
The foliage was painted with a knife and brush and the highlights were done with the knife. The paint was put on quite thickly using quick flicks, which were then softened here and there. To paint this kind of foliage, half-close your eyes and create an overall impression; don't try to paint every leaf.

angle to the first colour, you will pick up some of the first colour and create an uneven edge. For a clean, sharp edge, the brushmarks should follow the direction of the line or edge that you want to create. As a general rule, paint the darker colour first and the lighter one next to it – but be prepared to do the opposite when necessary. If you have a large colour area, you should avoid making a continuous line around it in one direction. For a broken or soft edge between two areas of colour, mix the two colours slightly on the canvas by applying the paint with random brushstrokes in different directions.

SCRATCHING BACK

Detail can be created by scratching back through the paint to the canvas but this effect should be used sparingly. This technique has been used on the lower part of the signal box in *Obsolete Signal-box, Kings Cross* (page 98), and to convey the driving rain in *The Red Umbrella* (page 98).

CONSISTENCY

Whether you use a knife or a brush, and whatever type of marks and softening you use, they should be echoed throughout the painting. If you use one type of mark in one area, and marks with a quite different character in another area, you will destroy the harmony of the surface texture. The same principle applies if you are using your finger to soften an area such as sky or foliage. Echo this softening in other parts of the painting – in shadows areas, for example.

Techniques

Technique is not an end in itself, rather it is a means of expressing what you want to say about a scene. You need to find your own way of interpreting what you see through the manner in which you apply the paint, by trying to develop a range of marks with brushes and palette knife.

The method of working described in the step-by-step sequence of *Clear November Light, Bull's Mill* (page 24) provides a good basis for working on a painting in one session. The bare bones of the composition are sketched in with charcoal. The whole scene is then blocked in with colour, using thin paint and concentrating on getting the right tone at the horizon. Use stronger colours in this underpainting than you want to end up with, as this will give vibrancy to the more accurate colours and tones that go over the top. You can use a

contrasting colour in the underpainting to create a very vibrant effect, such as in the sea area in *June Morning, Budleigh Salterton* (below).

To keep the colours in the underpainting lively, don't mix more than two together, and do not add white or they will lose their transparency and look dull. For very light areas, use the paint very thinly so that the white of the canvas shows through, or add just a touch of white. You can adjust tones that are too dark by wiping them back with a rag.

Before you start the next stage, you can mix about 20 per cent of quick-drying gel into the white on your palette. This will help the paint to dry quicker, especially the lighter colours.

Work the sky from the horizon to the top of the sky. Then start on the scene, again working from the horizon forwards. Put in the background

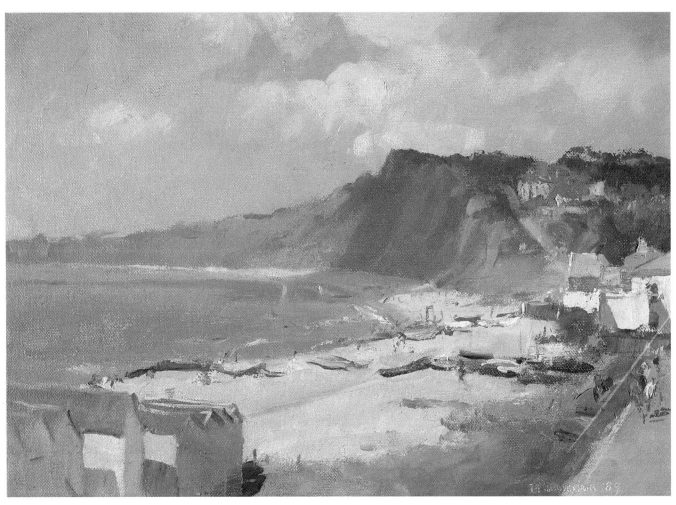

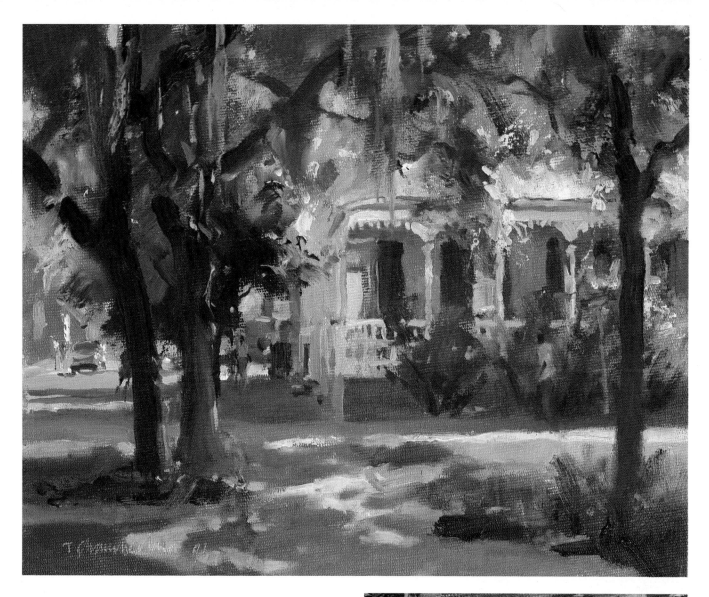

SAVANNAH, GEORGIA (20 x 25 cm/8 x 10 in)
Above and right, the brushmarks were kept lively and impressionistic to suggest the shimmering light, and a variety of marks have been used. The detail in the building was painted on over everything else, and was applied unevenly to suggest a light style of architecture. The paint was put on with a brush, using thin paint in the darker areas and thick paint where the columns and balustrade were catching the light.

The Spanish moss was painted with strong downward strokes, and the leaves were done with a brush. The highlights here and there were scumbled on with thick paint - known as impasto - using a palette knife.

JUNE MORNING, BUDLEIGH SALTERTON (25 x 35 cm/10 x 14 in)
Left, the underpainting in the sea was quite a strong pink, contrasting with the blue/green colour scumbled over the top. This gives vibrancy to the sea, and helps to create the impression that there are many facets in the surface of the sea picking up influences from the things around. Although the sea is predominantly blue, the complementary orange would have been too hot, so a cool pink was used instead.

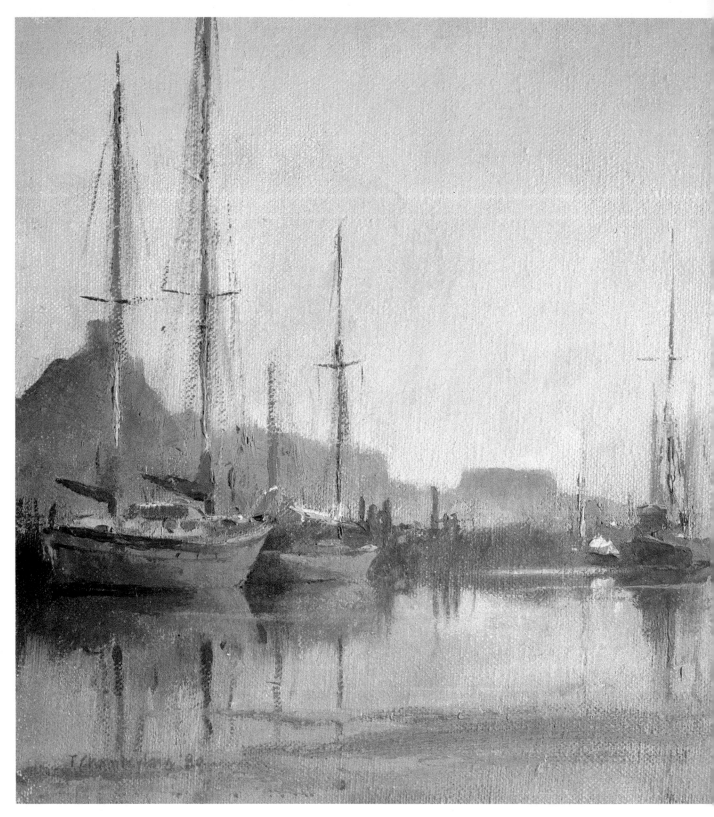

supporting areas first, then the main centre of interest, and the foreground last. When you have brought the whole painting up to the same degree of finish, make any necessary adjustments and add emphasis and highlights where they are needed.

When you get the painting back home, have another look at it and make any final adjustments.

This can be done the next day. If, however, you know that you want to change any areas of thick paint, scrape them off as soon as you get the painting home before they have a chance to dry. It is helpful to look at the painting in a mirror, as this enables you to see it anew and emphasizes any imbalance in the drawing, tones or overall lighting effect.

COASTAL MIST, SOUTHWOLD HARBOUR
(25 x 35 cm/10 x 14 in)
The sky was painted into the water with no indication of a change at the horizon. The horizon was only suggested by the far riverbank disappearing into the mist.

CLEAR NOVEMBER LIGHT, BULL'S MILL
(25 x 35 cm/10 x 14 in)

This was painted on a windy November afternoon with strong, clear light. The cast shadows were a strong foreground feature, and described the contours of the verges and road. The subject had a number of interesting features – buildings, a road, water, trees, fields, fences and fast-moving clouds – without being too complicated.

The centre of interest is formed by the house and barn and the trees around them. The bright orange on the barn roof was echoed by the corner of the house and reflected in the puddle below; there is not just one spot of bright colour. The vibrant colour around the centre of interest contrasts with the green on the left and the blue on the roof of the house. The darkest tones frame the centre of interest and pull the eye back to it so that the viewer's attention doesn't wander out of the picture.

The tree was moved slightly to the left, so that it was off-centre in relation to the lit, gable end of the house, and the whole centre of interest is off-centre within the picture area. The telegraph pole opposite the house leads the eye up to the clouds, and the tree leads the eye back down to the buildings.

Although it was a clear day, there is still aerial perspective. The colours are more muted as they recede into the distance. Slight linear perspective is apparent in the house and the road. The line of the eaves was above the eye level, and therefore sloped downwards slightly. The road is on the flat in the foreground, but slopes slightly uphill in the distance, so the verges would meet slightly above the eye level.

The fence in the foreground has been reduced to suggestions, and the left-hand section was stated early on and then left. The wood in the background was simplified down to a shape, and a few trunks and individual forms of trees have been indicated at the right-hand end where the wood thinned out.

The shadow on the road in the bottom left-hand corner is warm, but becomes cooler and darker against the lit area of road. The tones of the shadow and reflections in the puddle change in relation to the road, and the edge of the puddle is lost so that it doesn't create a visual barrier.

Step 1 *The scene is sketched in with charcoal. No detail is included, just the outlines of the main shapes and masses. To make changes at this stage, lightly flick the charcoal off with a rag. Don't use a rubber because it tends to rub the charcoal into the canvas. When you are satisfied with the composition, blow on the drawing to remove the surplus charcoal dust.*

Step 2 *All areas of the canvas are blocked in with paint thinned with turps and mixed with a little gel to speed up the drying time. A size 10 brush is used except for very small areas. Everything is treated as flat shapes, and no details are included.*

The shadows on the road, put in with ultramarine and a little burnt sienna, are bluer than required, to influence the next layer of paint. The red bush is overstated with a warm colour, using alizarin crimson and a touch of cobalt blue, to give it some importance and bring it forward against the trees behind, which are warm but further away. The roof of the

barn is stated with a strong, raw colour, using alizarin crimson, burnt sienna and cadmium orange, so that it sings out. It will be modified later.

The shadows in the verge in the bottom right-hand corner are put in mainly using sap green, with some alizarin crimson and burnt sienna. The fields are put in with sap green and a little yellow ochre. The wood is put in with brown.

Paint is then wiped off on the lower part of the main tree trunk, on some of the branches of the main tree, and on the light part of the verge under the telegraph pole.

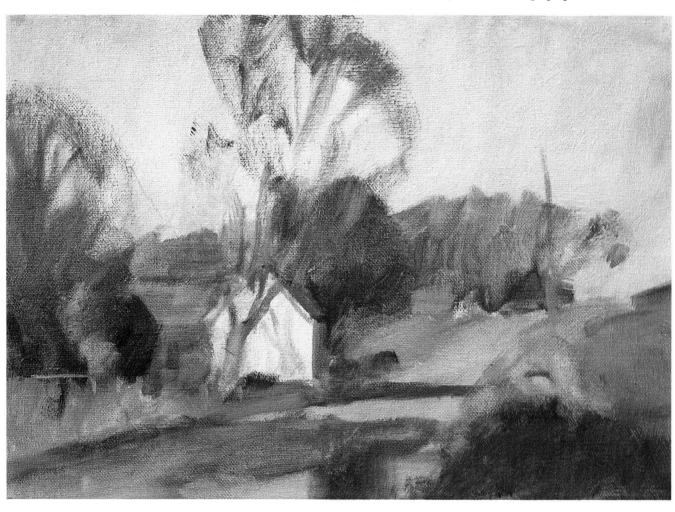

Step 3 *The sky is put in mainly with a palette knife. It is worked from the horizon up to the undersides of the clouds. A patch of the strongest blue at the top of the sky is put in early on to provide a colour to work up to. Darks are put in for the undersides of the clouds, and softened with a finger. Then the light patches in the clouds are put in with the brush and softened. The lights are very warm, and no pure white is used. The sky is done in one working over the underpainting.*

The strongest blue, at the top of the sky, is cobalt blue modified with a little burnt sienna and a touch of yellow ochre, and the sky colour lightens in tone as it recedes towards the horizon. A lot of warmth is worked into the sky because a warm light is permeating the whole landscape.

The landscape is done next, starting at the horizon. The subtle grey in the distance on the right, made from burnt sienna, cobalt blue and white, is put in with the knife and the edges are softened with a finger. The foliage in the wood is scumbled on with the knife, using a warm green made with

yellow ochre and cobalt blue, and a lot of the underpainting is allowed to show through. The distant fields are put in with mixtures of yellow ochre, sap green, viridian and burnt sienna to create different tones and warm/cool contrasts. The darks in the hedge and on the side of the distant building are stated with variations on grey, and the lit roof and face of the building are indicated as rough, uneven shapes, again with the knife.

The shape of the red tree is defined by scumbling with the knife, and some cool areas are added in the foliage. The trunk is put in with a brush, as are the cool blue roof of the foreground building and its shadow side. Some colour is added to the lit end of the building and the shadows are indicated with a brush. A final, lighter-toned layer of paint is scumbled over the barn roof to indicate the light. The light areas on the road are put in with yellow ochre, a touch of alizarin, a touch of blue and white, and are painted around the shadow shape of the underpainting.

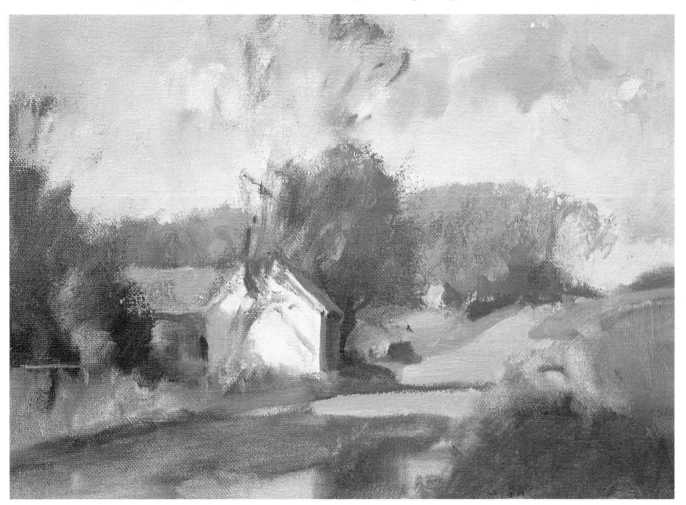

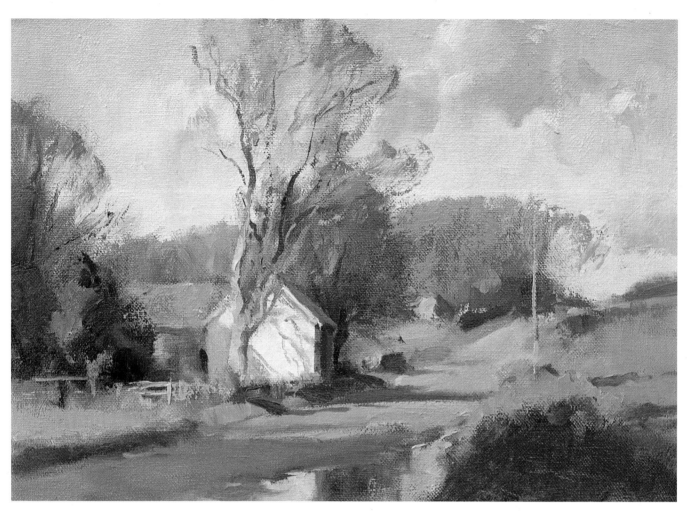

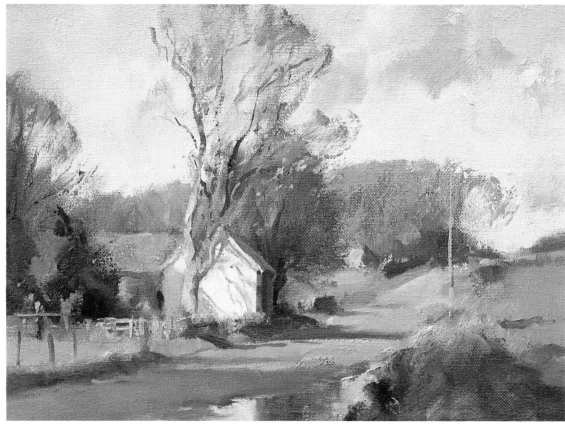

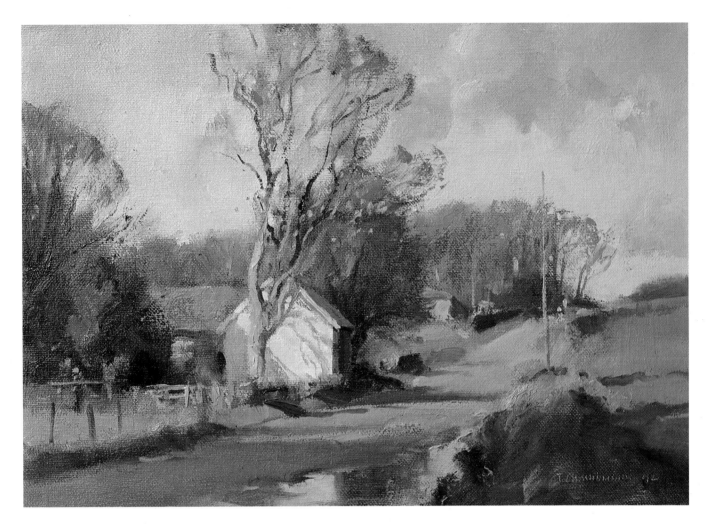

Step 4 *Top left, the landscape is worked over again from the horizon to bring all areas of the painting up to the same degree of finish. The nearer fields on the right are put in with the knife, and the shadows across them with a brush. On the main tree, the ends of the branches are put in by skipping the side of the brush over the canvas, and then drawing into the paint with the palette knife and a sable brush to create broken lines. The red on the side of the building is restated. The reflections in the puddle are added, but the colours are muted compared to the building itself - the lights are darker and the darks are lighter. A few more branches are added to the left-hand tree, and the tree on the far left of the picture is brought up to the same degree of finish. The shadow to the left of the barn is put in with the knife and softened.*

The fence posts in sunlight are put in with thick paint to make them stand out. Warmth is added to the road in the foreground, and the foreground verge is given a little form with the addition of a few shadows and lights. The area of verge under the telegraph pole is given texture by applying thick paint with a brush, and the telegraph pole is restated with the side of the knife.

Step 5 *Bottom left, by this stage the bulk of the painting is finished, and it's now a matter of making adjustments and adding emphasis and highlights. A few stippled marks are added for the stray autumn leaves on the main tree, and behind the fence on the left. A touch of a light, pinky tone is added to the verge in the foreground to suggest dry grasses.*

Step 6 *Above, the final stage is done in the studio. The telegraph pole is extended above the line of the wood. Flicks of light are added in the distance on the road, and more interest is added behind the hedge by the far barn to indicate something happening there. The shadow is more clearly defined where it passes over the verge into the field, under the main telegraph pole.*

The dark at the left-hand end of the barn roof is toned down. More warmth is introduced into the end of the house where it's catching the full force of the sun and on the barge-board along the edge of the roof. Thick paint is put on here with a brush, painting round the shadows. The tree trunks are added at the edge of the wood and little patches of sky are painted over the foliage.

Practice

The painting of Bull's Mill includes a very wide variety of marks: brushes have been used flat and on their sides, the palette knife has been used flat and on its edge, the sable brush has been used to create thin lines, and there is scumbling, stippling, finger softening and impasto. Experiment with all these ways of applying the paint, and incorporate as many as possible into all your paintings to keep your work lively.

Detail from HIGH SUMMER, THE CASTLE GROUNDS (page 32)
Use brushes and a palette knife to create the variety of marks that have been used here. Look at the painting in terms of patches of colour, rather than as the objects and figures depicted, and copy them as accurately as you can.

With the exercises on these pages do not worry about matching the colours exactly, although you can turn to page 46 for advice on mixing darks and greys.

CORNER OF PONSONBY PLACE
(15 x 20 cm/6 x 8 in)
Right, the texture of the brickwork is created by using directional brushstrokes in the underpainting, as is the foliage on the right. The channels in the rendering are roughly stated, and the bars on the windows and the balustrading are suggested but not in any detail. The cars and figures are treated as very simple shapes.

Detail from AUTUMN AFTERNOON, LOWER POOL (page 31)
Apply a warm underpainting of burnt sienna mixed with a little yellow ochre. The water is created by painting over the underpainting with blue/grey, allowing some of the underpainting to show through. Linear marks made with a brush and knife define the structure of the barge, and the dark shadow on top of the barge is scumbled on. The highlights are added with thick paint.

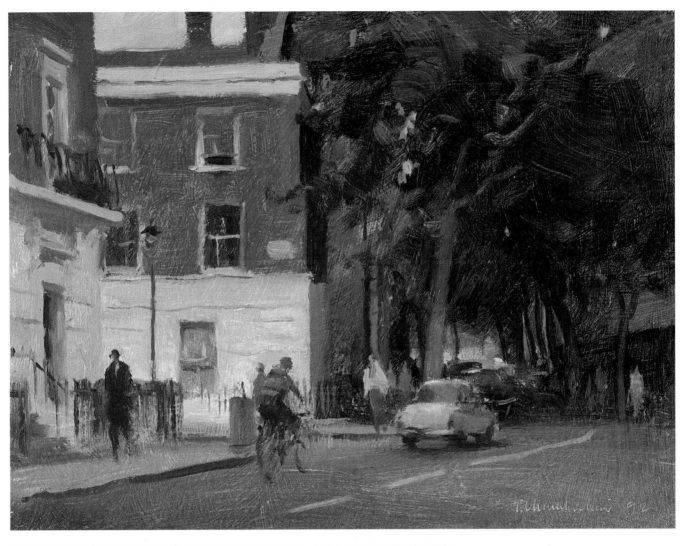

Detail from SILENT SNOWSCAPE
(page 91)
This is good for experimenting with the effects that can be created by letting the underpainting show through subsequent layers of paint. The snow area has a warm underpainting, and the tree is also roughed in at this stage. The snow is applied so that areas of warm colour show through it to create the dried grasses in the foreground and the larger warm areas near the tree. Hold a sheet of white paper against the snow to see the depth of tone and variety of colours used to paint it.

Tonal Values

The tonal values – or light-to-dark range – in a scene are more important than colour in organizing a picture and conveying a sense of depth. Before you start painting, you should establish which is the lightest light and the darkest dark, as everything else will fall between them. Then compare the relative tonal values of all the other elements in the scene.

The weather affects the range of tones you can see. On a clear, sunny day a greater range of tones will be apparent and a wide range will extend further into the distance. On a dull or misty day there will be fewer extremes of tone, so the range will be smaller. This has the effect of simplifying shapes and flattening the distance.

SEPTEMBER, WATERFORD MARSH
(25 x 35 cm/10 x 14 in)
The misty atmosphere simplified this scene. The animals by the fence on the left were seen as simple shapes against the light, as was the fence itself and the little bit of hedge. The large foreground shadow forms a strong shape, but is broken up by the two animals in the foreground, one of which is strongly stated in silhouette against the light, while the other is much lighter in tone.

In a simple composition such as this, you need to give a lot of thought to the positioning of the different shapes, their relative sizes and the pattern that they form across the whole picture.

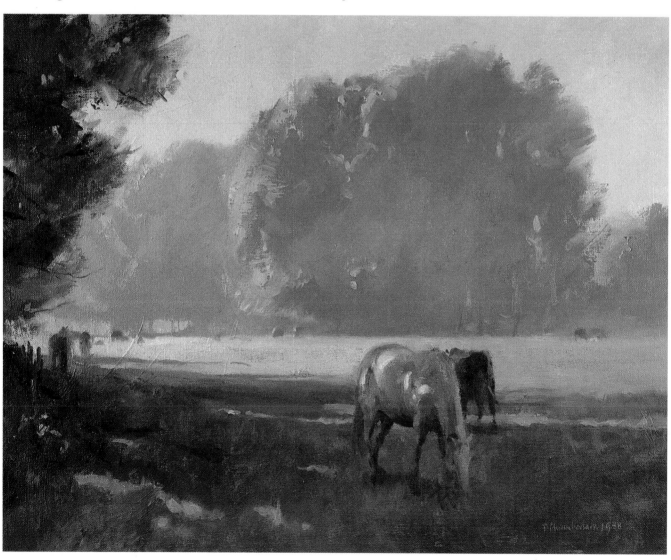

AUTUMN AFTERNOON, LOWER POOL
(25 x 35 cm/10 x 14 in)
This was painted on an atmospheric autumn day with diffused light. It was painted looking into the light and this, together with the mist in the air, helped to simplify the shapes. The strongest contrasts occur around the barge in the foreground, set against the light reflected on the water. The main area of reflected light is echoed by other specks of light on the water.

As the scene recedes towards Tower Bridge, the tones become less contrasted, until in the distance they almost merge with the sky tone. The smoke in front of the right-hand tower of the bridge appears light where it catches the sun just above the water, but changes tone as it rises, so that it appears slightly darker against the sky.

When looking at a scene in terms of lights and darks, it can be difficult to be sure which colours are lighter or darker than others. To work them out you need to keep looking at one tone in relation to another. Looking through half-closed eyes can help, as this cuts down the detail and reduces the different elements to simple shapes whose relative tonal values become more obvious.

If you have trouble assessing the tonal values of different areas of colour, you could make a tonal scale from white to black, with about nine graduated steps between them, using charcoal or black and white paint, and try to relate the tones of different colours in a scene to this. Also, compare the tones in

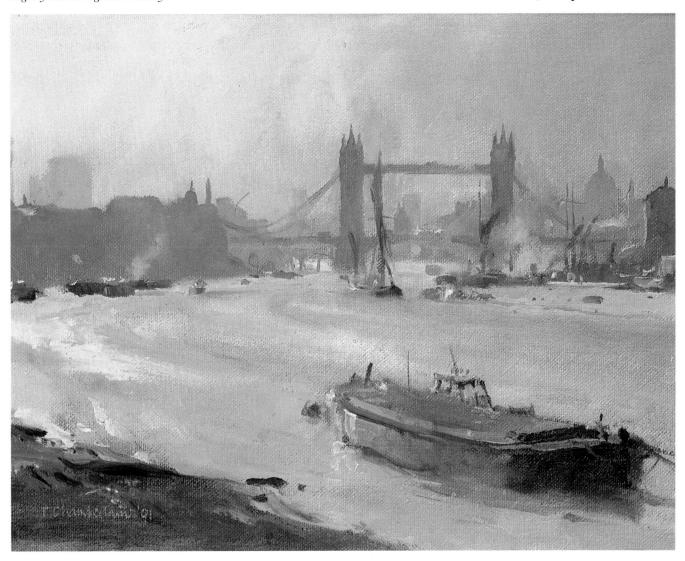

the foreground, middle distance and far distance. Some objects in the middle distance, or even the far distance, may look quite dark. However, you should compare them to the tone of foreground objects as well as to the tone of the other things around them. Distant objects are often not dark in relation to foreground objects – they appear dark only in relation to other things close to them in the distance.

White subjects, such as snow, white fences or clothing, can be misleading if they are not in direct sunlight. Do not assume that because something is white, it is light in tone. Look at it carefully against other areas in the scene, especially well-lit areas, because if the white is in any degree of shadow, it is likely to be a darker tone than you at first thought.

Look carefully at enclosed areas of shadow, such as those under trees. Everything will be darker because very little light is being reflected from one surface to another. If such an area is set against a sunlit patch, the contrast will be accentuated (see *High Summer, The Castle Grounds*, this page).

TONE AND COMPOSITION

The arrangement of tones within the picture is an important aspect of composition. If the lightest lights occur at the edge of the canvas, they will tend to draw the eye and the picture will feel unbalanced. In this case, you need either to rearrange the composition in order to move them into the picture area, or to tone them down. If a dark area makes an ugly shape or is badly positioned in the picture frame, change it, move it or lighten it slightly.

HIGH SUMMER, THE CASTLE GROUNDS
(25 x 35 cm/10 x 14 in)
This was painted on a clear, sunny day, so the tonal contrasts continue further into the distance. Even so, the dark area under the roundabout is not as dark as the dark area under the middle tree or that under the bush on the left-hand side. The areas of quite rich darks accentuate the sunlit areas, and the alternation of light and dark areas continuing into the background contributes to a sense of depth.

Because the figures under the tree are in deep shadow and contrasted with the sunlit area beyond, their light-coloured shirts appeared as quite a dark tone.

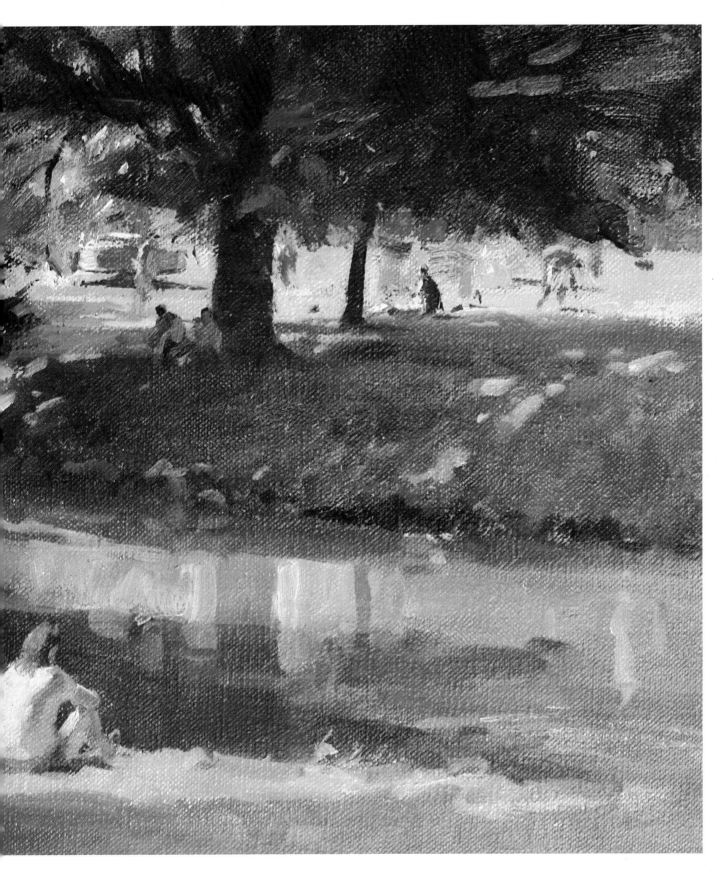

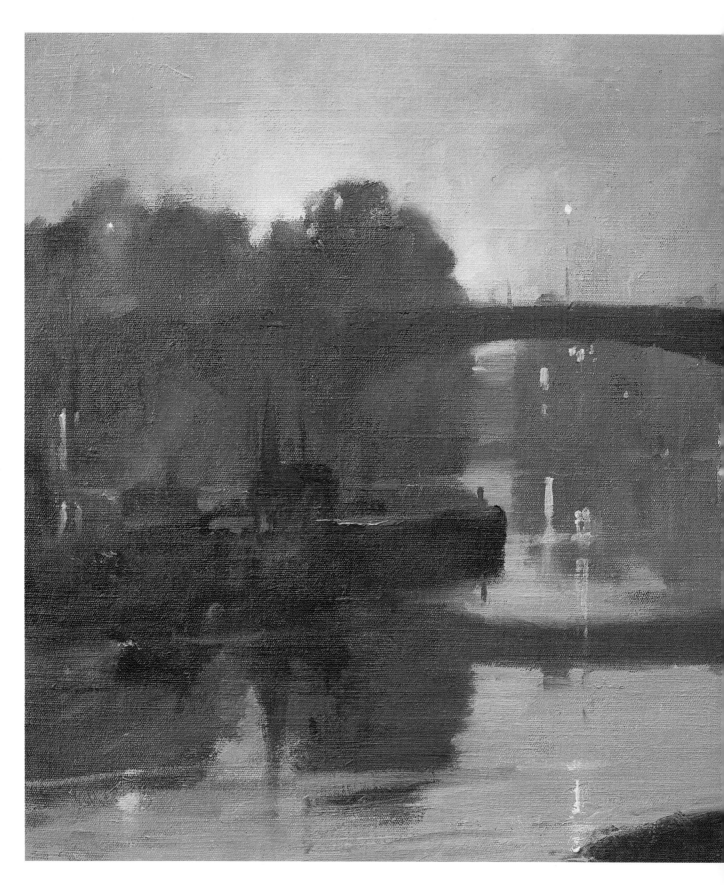

When you are composing a picture, bear in mind the principle of seeing things as light against dark and dark against light (counterchange), but to varying degrees. Strong tonal contrasts can be used to create emphasis where you want it in the picture, because they tend to attract the eye, and they should therefore be reserved for the centre of interest. Although in other areas of the painting you should be painting light against dark and dark against light, the degree of contrast should be smaller in relation to the main area – see *Autumn Afternoon, Lower Pool* (page 31) and *Shipping off Falmouth* (page 2).

The manipulation of tonal contrasts is one of the main ways of creating a sense of space and distance in a painting. It has already been pointed out that the atmosphere reduces the tonal range that we see in a scene as we look into the distance. In the same way, in a painting the degree of contrast in a scene should gradually reduce towards the distance.

Tonal effects are relative, and depend on different tones being seen against each other. Therefore, even if you are painting a predominantly high-key or low-key scene, it is important to include touches of a contrasting tone, though not a strongly contrasting one, to set it off.

Some paintings, such as *Night, Kew Bridge* (this page), are just about tonal contrast. Colour takes on a very secondary role, and the arrangement and pattern created by the tonal areas are all-important.

NIGHT, KEW BRIDGE
(50 x 60 cm/20 x 24 in)
The original for this was painted on the spot under a street lamp, and this was copied from it in the studio at a later date. Because the scene was painted in very poor light, all the elements were reduced to simple shapes, shown up by the strong light in the sky behind the trees on the left.

The shape of the bridge and the reflection in the water below it forms one of the strongest elements in the picture. The small figure on the right contrasted against the bright water, gives the picture life and forms the main centre of interest. The light under the bridge creates a subsidiary area of interest.

The eye is led from the small figure, to the boat silhouetted under the bridge, to the bridge itself. The tones merge as they recede into the distance and you cannot tell where the houses along the bank meet the water. The ghostly shapes of boats and glints of light break up this shadow area.

Practice

There are no short cuts to understanding tone; you need to spend a lot of time working on site to see tones correctly and use them to organize a painting. Painting in monochrome is a good way to get to grips with tonal values because you can concentrate on assessing and matching tones without having to worry about colour. Try these two exercises, and then repeat them working directly from a scene out of doors.

BARGE AT ERITH
(15 x 20 cm/6 x 8 in)
The greatest contrast is in the foreground, where the barge meets the lit water, and your interest is drawn to it straight away. From there, the picture recedes into the distance through the use of reduced tonal contrasts. Copy this picture to get used to mixing and using a range of tones, and then paint a picture in monochrome on the spot. This was painted using a mixture of raw umber and cobalt blue (see page 46) plus white.

If you have trouble sorting out the relative tonal values in a scene, limit yourself to about seven tones. Mix them on the palette before you start, and relate everything in the setting to one of them. This will help you to simplify the picture.

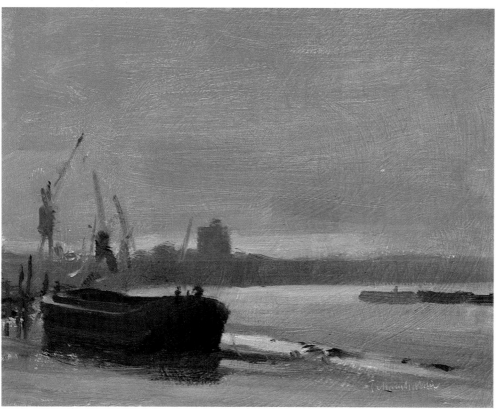

RAIN IN THE AIR, NOTTS
(20 x 15 cm/8 x 6 in)
The scene was lit with a very diffused light, reducing the range of tones. Copy the colour version opposite in monochrome, starting with the sky, and concentrate on matching the tones used so that you see the very fine differences between them. Then compare your painting with the monochrome example above. This was painted with a mixture of alizarin crimson and viridian plus white.

Composition

SULTRY AFTERNOON IN AUGUST,
KING'S REACH
(40 x 60 cm/16 x 24 in)
The main centre of interest is St Paul's
and its surrounding buildings in the mid-
distance, shown up by the sunlight and
placed off-centre in the picture. They are
balanced by a little light on the bridge in
the foreground and the passenger boat
going downriver.

The sky and background skyscrapers
are treated in a darkish tone in order to
throw up the lit buildings. The foreground
trees and near bank are also in shadow to
highlight the centre of interest. An S-
shape follows the riverbank, up to the
main skyscraper and into the sky.

BEACH AT BEER, DEVON
(17 x 25 cm/7 x 10 in)
Right, a diagonal line follows the
outline of the cliff down to the beach
and along the waterline to the opposite
corner, dividing the picture unevenly
and creating an interesting shape. The
small, busy area on the beach is
balanced by a large expanse of sea and
sky. The eye is drawn into the mid-
distance by the bright red figure on the
beach, and from there across the warm
reflection on the water to the sail in the
distance.

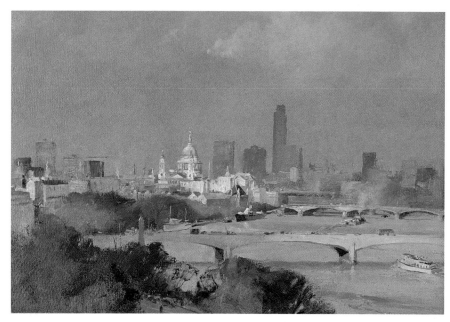

Composition, or the arrangement of elements within the painting, is fundamental to creating an appealing and well-balanced picture that holds and directs the viewer's attention. However well a scene has been observed and painted, if the painting does not hang together as a whole it will not succeed. In addition, all good paintings have underlying abstract qualities, such as shapes that are interesting in their own right, linear patterns or rhythm, and you should look for ways of introducing these.

The elements should be well placed within the picture frame, and arranged so that the viewer's attention is drawn to the main area of interest, supported by secondary features and more simply stated background areas. Certain devices can be used to create emphasis, and to provide balance and unity throughout the picture as a whole.

COMPOSITIONAL SHAPES
There are a number of compositional shapes, illustrated on pages 40-41, that can be used as the basis for the overall arrangement. These break up

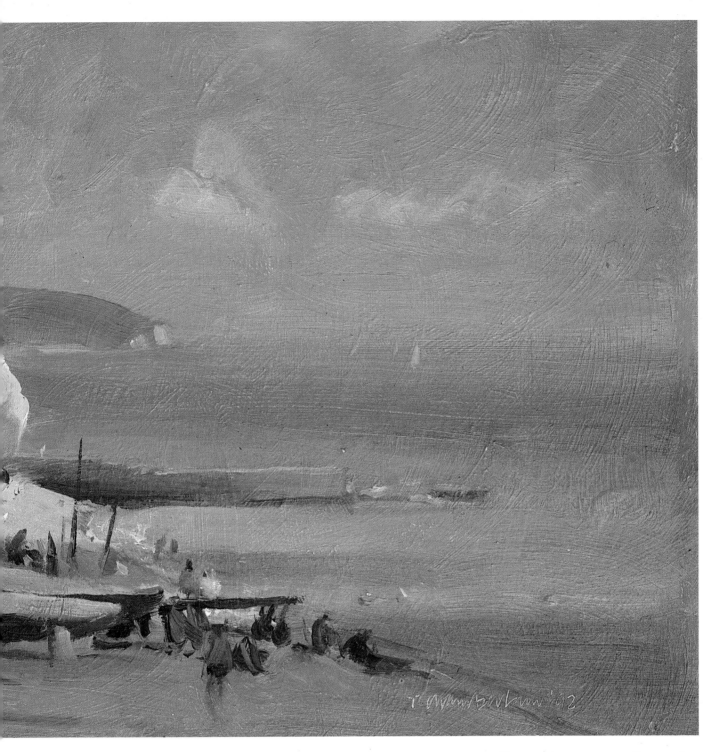

the canvas in a pleasing way and help you to organize the elements so that the viewer's attention falls where you want it. They also prevent the eye being led right out of the picture. You should treat these shapes as guides, and play around with them in order to create an interesting picture.

EMPHASIS, BALANCE AND UNITY

There are a number of elements that need to be considered in addition to the overall arrangement, although you may bring them into play to a greater or lesser degree in different pictures according to the subject and the effect you want to create.

You need to think about the relationship between shapes and masses in the picture. Shapes are the areas that will be treated in a flat, two-dimensional way, and masses are those areas that will be given solidity and volume. These need to be distributed across the picture in order to create a balanced effect. If you produce a painting made up of flat shapes and then introduce one mass, the painting will look wrong.

Look for lines or implied lines that follow through the picture and link one area to another, leading the eye around the scene, such as a line that follows down one person's arm to another person nearby. Directional lines, which can be horizontal, vertical or diagonal, such as those formed by fences, also lead or point the eye in certain directions. A composition based on radiating lines is an obvious example of this.

A rhythm can be set up through the whole picture by the repetition of a certain shape. For example, a circular rhythm can be created running through clouds, round the tops of trees and down into foliage.

L-shape

This consists of a strong vertical on one side of the picture and a strong horizontal foreground element across the picture. The main centre of interest occurs within the angle. See September, Waterford Marsh *(page 30).*

Diagonal

A diagonal line runs across the picture. It should create an interesting shape and divide the picture into uneven parts, so avoid having the line running from corner to corner. See Beach at Beer, Devon *(page 38).*

SUMMER BY THE THAMES
AT RICHMOND
(35 x 50 cm/14 x 20 in)
A busy pattern runs through the foliage, shadows and reflections in the water. Strong interlocking V-shapes, created by the foliage and shadows, work in contrast to the overall pattern, and the centre of interest falls at the apex of the inverted V formed by the foliage. The railing, which was prominent, has been suggested with broken lines so that it does not form a barrier. The eye carries on through it to the boats in midstream.

S-shape

This is created by a river or road, for example, curving up through the scene, and can continue into the cloud formations in the sky if appropriate. It draws the eye to the main centre of interest, which is often in the middle distance. See Last Light, Isleworth Creek *(page 44).*

O-shape or tunnel

This can be formed by two trees, buildings, or any combination of elements that link up to form an O. The centre of interest is seen through the O, but make sure that it is placed well off-centre as this arrangement can err on the side of symmetry. See Entrance to Clink Wharf *(page 42).*

Group

Groups of boats, trees, people and so on should be placed off-centre. The rule of thirds is a good guideline to follow. Imagine the canvas divided into thirds horizontally and vertically, and place the group around one of the points where two lines intersect. See Summer Light, West Mersea *(page 83).*

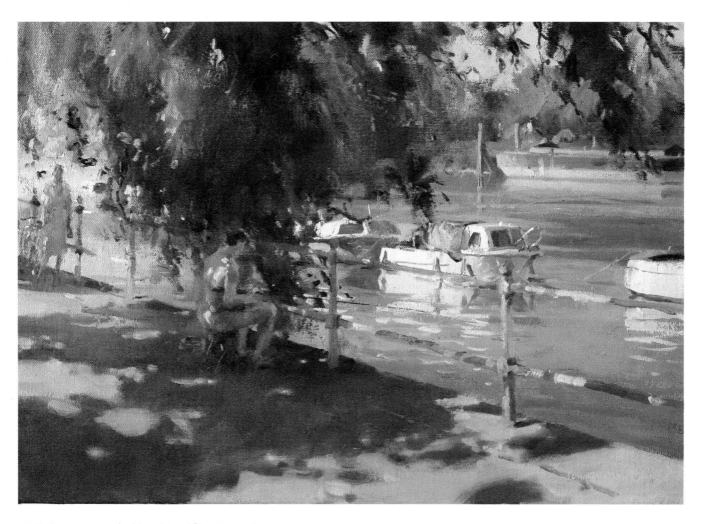

Triangle
A triangle is created by placing centres of interest at either side of the canvas, with something such as a distant feature or interesting cloud formation near the top. See Frosty Fields, Aston *(page 90).*

Radiating lines
Suggested or actual lines made by roads, fences, the skyline, buildings, fallen trees, branches, waves or even clouds converge on the centre of interest. See Felled Trees, Waterford Marsh *(page 108) and* Rainbow, Brighton Foreshore *(page 63).*

Pattern
This type of composition is based on creating a pattern running through the whole picture. For example, it could be a circular pattern using cloud forms, foliage and shadows, or a rectangular pattern based on houses built up a hillside. See Summer by the Thames at Richmond *(page 40).*

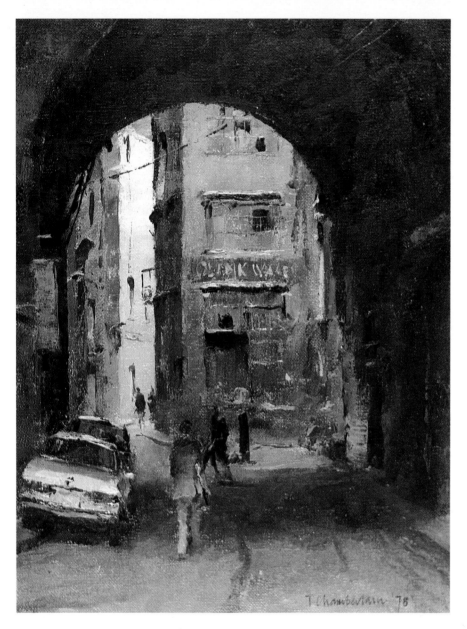

ENTRANCE TO CLINK WHARF
(25 x 35 cm/10 x 14 in)
Left, in this example of the O or tunnel composition, the O shape supporting the area of interest is off-centre in the picture frame, and what is happening within it is also very much off-centre to avoid a symmetrical picture. The car on the left contributes to the arrangement, as does the man walking into the picture in the foreground, because they help to move the interest off-centre and lead the eye into the gap between the buildings where the light is shining on the wall.

SUMMER, ALBERT MEMORIAL
(45 x 35 cm/18 x 14 in)
The trees meeting across the top of the picture and the shadows across the road link up to create an O shape, with the centre of interest positioned to the right within it. The shape of the O is eccentric, with the sky to the right. People lead in to the main subject, and even the Albert Hall in the background is not centred on the memorial.

You also need to consider tonal balance, discussed in the previous chapter, and colour balance. If you want to use colour to draw attention to the centre of interest, you can use a quite striking colour. However, it must be in key with the rest of the picture so that it does not jump out of the canvas, and should be echoed in other areas.

Feel free to adjust elements in the scene to suit your arrangement. You can move elements such as trees, make them lean more, shorten them or leave them out altogether, or add things, if it will improve the composition (see the three paintings of the Hungarian State Circus on pages 47-49). Group elements such as trees or boats together – do not string them out across the scene – and place the group where it best fits the composition. If you have a strong horizontal line, such as a horizon, break it with trees, masts, telegraph poles and so on.

USING A VIEWFINDER

A viewfinder is very useful for discovering the best arrangement, and for deciding whether to use a landscape or portrait format. If you have trouble choosing a format, think what really interests you about the subject and be guided by that (see *Last Light, Isleworth Creek*, page 44). If the main subject is tall, do not use a landscape format, and vice versa.

Look at the whole area within the viewfinder; do not just focus on the centre of interest. Be aware of where lines or implied lines formed by the skyline, roads, hedges and so on cut the edges of the picture area and whether these create interesting shapes within it. If these shapes are ugly or repetitive, adjust your viewpoint or make some adjustments in the painting. This is also a good time to consider the balance between shape and mass, and tone and colour.

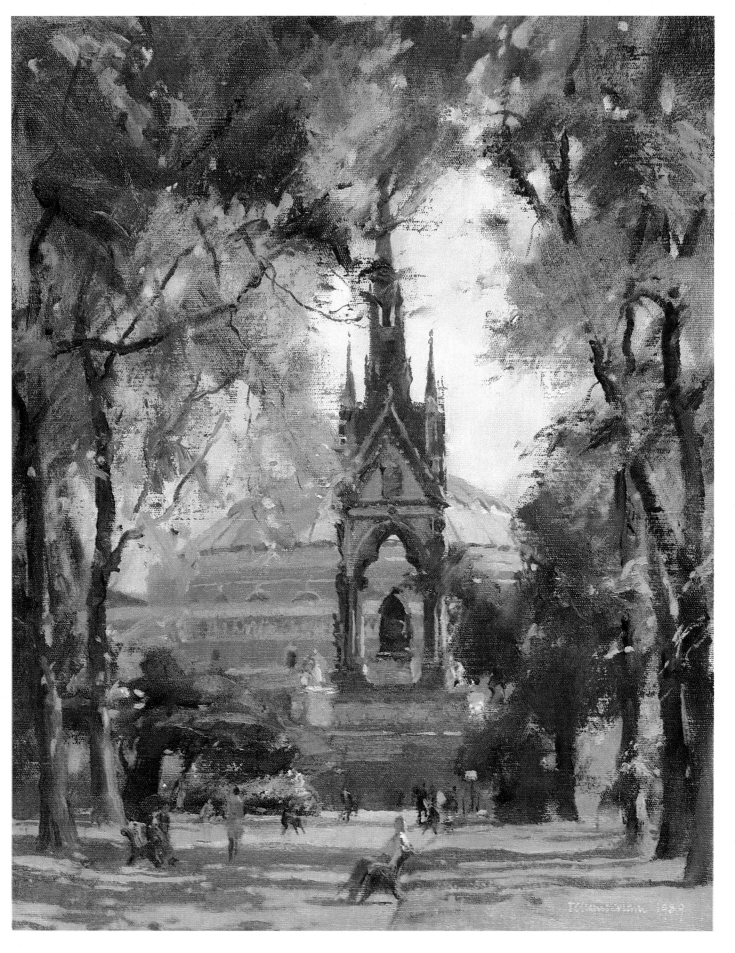

Practice

Many scenes offer several compositional options, as can be seen in this example. The vertical format chosen for the main picture suits the inclusion of the creek, but there are other possibilities, depending on what aspect of the scene as a whole is to be emphasized. Having studied these alternatives, find a scene and frame it up in different ways in order to explore all the possibilities. Also try moving the various elements around in order to create the strongest composition possible. You could work in a sketchbook for these exercises, or make small colour sketches on card.

> ## DO'S AND DON'TS
>
> **Do** focus on one main area of interest.
>
> **Do** look for interesting shapes and patterns.
>
> **Do** keep strong contrasts away from the edges of the picture.
>
> **Don't** place anything important in the dead centre of the picture.
>
> **Don**'t make the picture symmetrical.

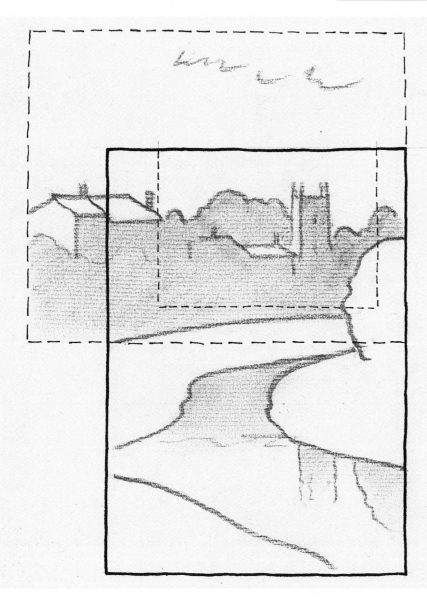

LAST LIGHT, ISLEWORTH CREEK
(25 x 17 cm/10 x 7 in)
The composition selected here includes the creek and the buildings in the distance. This is an S-shape composition, with the interest set very high in the picture. The creek forms a strong supporting feature in the foreground, leading the eye to the church tower. The whole scene is treated as simple shapes and masses.

A horizontal composition centred on the church and the evening sky, leaving out the creek in the foreground, could have been chosen. The simplicity of the subject is retained because of the strong shadow area.

The picture could have concentrated on the church as an architectural feature, while retaining the effect of the atmosphere and light. In this case, the other buildings would need to have been given more definition and interest.

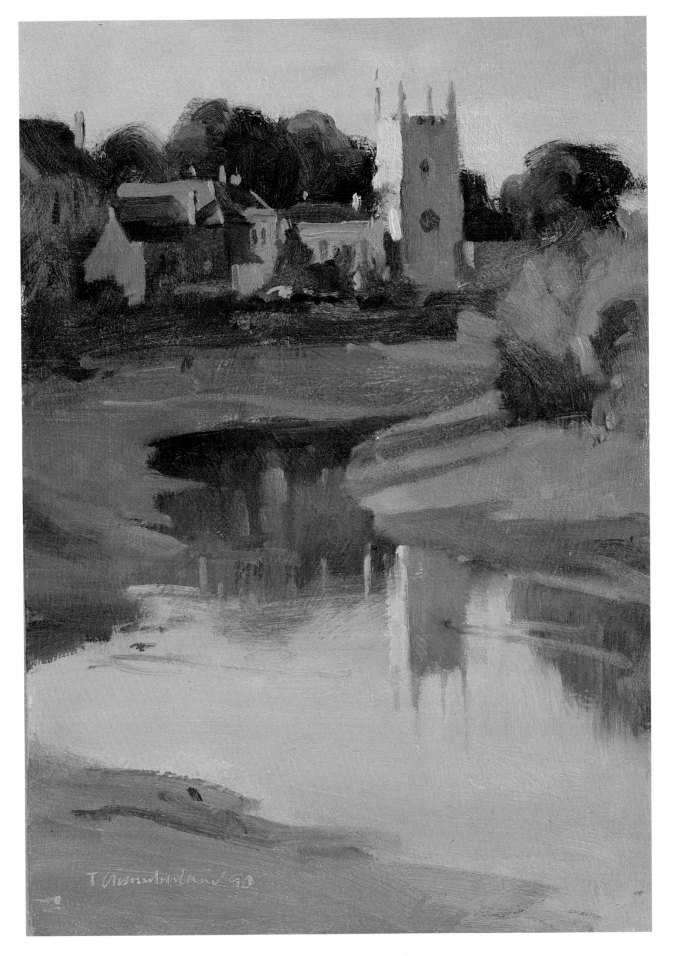

Colour

To begin with you will not need many colours, as it is much better to mix colours than to use a large range straight from the tubes. You can add extra colours that you find you need, or particularly like, at a later stage.

Always use artists' quality paints, unless you are just starting out and want to get the feel of the paint. Students' quality paints contain fillers and extenders, and are made using synthetic substitutes rather than real pigment, with the result that the colours are far less intense and often almost disappear when they are mixed with other colours. Good-quality paints are more expensive, but the colours are truer and they go much further as they contain a higher proportion of real pigment.

THE BASIC PALETTE
The following colours should form the basis of your palette. This selection need not vary throughout the year, although you will probably use more of some colours than others in particular seasons - more warmer colours such as yellow ochre, burnt sienna

Burnt umber and ultramarine

Raw umber and cobalt blue

Alizarin crimson and viridian

If you can mix the darks, greens and greys right, with careful observation the other colours should follow on quite easily.

Darks
You can get good darks without using black or paynes grey. These mixtures all produce strong dark tones.

Viridian and yellow ochre plus white

Ultramarine and cadmium yellow plus white

Prussian blue and cadmium orange plus white

Cerulean blue and raw sienna plus white

Greens
Greens do not have to come straight from the tube. You can create a variety of greens by mixing blues and yellows, and these can be adjusted by adding a third colour, such as a touch of red if the green is too bright and you want to tone it down a little. The yellow influences the nature of the green more than the blue does, so if you want a very sharp, cool green, use a cool yellow such as lemon yellow; if you want a warm green, you need to use a warm yellow such as cadmium yellow or yellow ochre.

Light red and prussian blue plus white

Burnt sienna and cobalt blue plus white

Alizarin crimson and viridian plus white

Greys
The greys illustrated here can be varied, or given a definite warm or cool cast, by adding more of one colour than the other, or by the addition of a third colour. For example, a little raw sienna or yellow ochre added to the light red/prussian blue mix would make it quite warm.

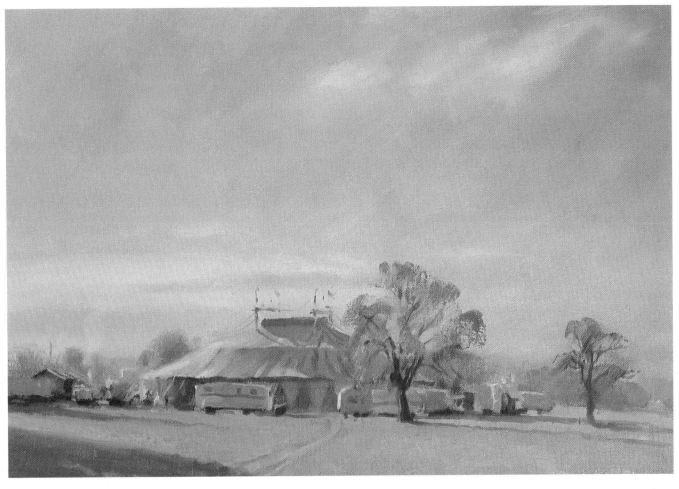

and browns in the autumn, more blues in winter and more greens in spring and summer.

Titanium white: this is a very white white that does not lose its intensity with time, and is good for mixing with other colours.

Yellow ochre: this is useful throughout a painting, in skies, for mixing greens, and for warm, light areas. It is opaque, and is good for toning down other colours or mixes that are too bright.

Burnt sienna: this is useful for mixing sky colours, throughout a painting for warm areas, and for mixing darks.

Alizarin crimson: this is quite strong, and should be used sparingly. It is transparent but stains the canvas quickly. Mixed with white, it makes a very cold pink.

Viridian: this can be fierce used on its own. Modified viridian can be used on the cool side of

THE CIRCUS ASLEEP
(35 x 50 cm/14 x 20 in)
This was painted shortly after dawn, when the sun was very low. The atmosphere was slightly hazy and the colours were quite muted but positive. The dew was masking the true colour of the grass and reflecting light from the sky, but some of the local colours on the big top and caravans were coming through.

The light was an important feature and has been interpreted through the colours used. The overall atmosphere of the painting is bright but on the chilly side, an effect created by the use of pale mauves and cool pinks and greens. There is quite a lot of white in the colours, cooling them down, and touches of warm colours to set them off. The colours have been blended throughout the canvas to create a soft effect.

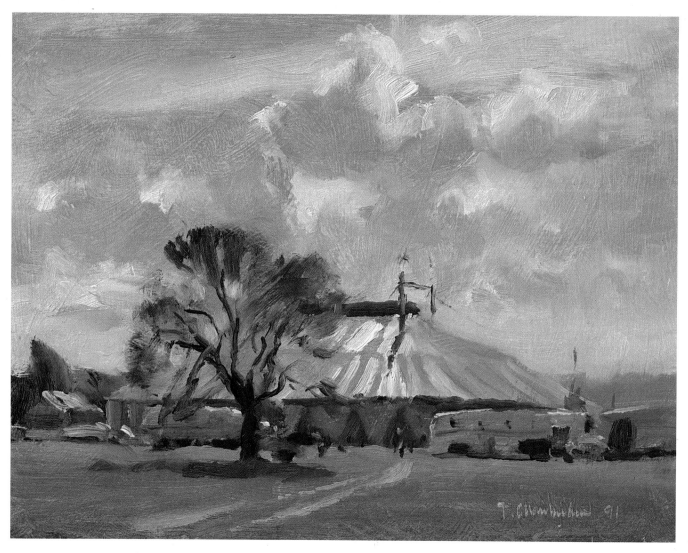

foliage, mixed with blue or with burnt sienna, depending on whether you want to create a cool or warm area of shadow.

Cobalt blue: this is useful for skies, and in the background when modified with another colour. It also makes quite fresh greens.

Ultramarine: this is a darker blue than cobalt. It is good for mixing with burnt umber to make the darkest darks.

Burnt umber: this should be used mainly for making darks. On its own, it is a rather dull brown.

ADDITIONAL USEFUL COLOURS

Cadmium yellow (light): this is a yellow with zing.

Light red or **Venetian red:** useful for local colour on buildings.

Cadmium red: you may occasionally need a spot of bright red for something specific.

Sap green: this is quite a bright, fresh, transparent green that is useful for underpainting because the unmixed colour gives a richness and vibrancy to subsequent layers of paint.

THE CIRCUS AT NOON (15 x 20 cm/6 x 8 in)
At noon the direction of the light had changed and was striking the roof of the big top. The tree has been moved in order to create the centre of interest around the roof, with the pathway leading the eye to that point. A strong, warm underpainting has been allowed to show through on the roof, and very light directional marks have been placed here and there to create the striped effect.

The sky is influencing the colours on the roof, so the same mauves have been used on the stripes as on the undersides of the clouds. A warm sienna underpainting shows through the grass in the foreground to give warmth. As the grass recedes towards the big top, it loses colour and becomes lighter in tone.

DO'S AND DON'TS

Do use artists' quality paint.

Do use a limited palette and mix the colours you want.

Don't use black or paynes grey.

Don't let colours get overmixed or muddy.

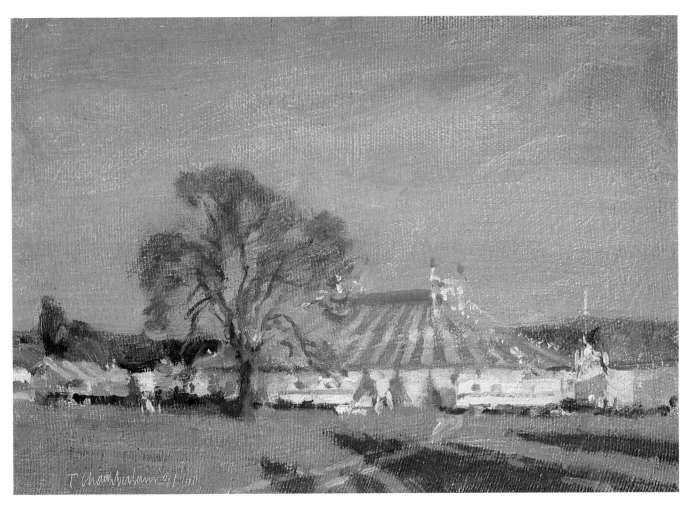

EVENING (17 x 25 cm/7 x 10 in)

*By evening, the sun had moved round to a setting position.
The warmth of the sun, which had been shining all day, gave
a very warm cast to the whole scene, bringing out vibrant
colours in the tent and side-shows. Light fell on the near right
face of the tent, and this has been indicated by accentuating
the pinks in the roof. Moving away from the sun into the
shadow of the tree, a cool effect has been created where the tree
shields the roof from the light. The shadow is picking up blues
and other cool colours from the cool part of the sky.*

*The scene has been painted in predominantly warm colours
but cool colours are needed for the warm colours to sing
against. The bright colours at the centre of the scene have been
echoed throughout the painting. For example, the pinks on the
roof are echoed in the foreground and in the clouds.*

COLOURS TO AVOID

Black and paynes grey should be avoided in oil
painting because they are 'dead' colours, creating
holes in the picture. In addition, there is no actual
black in any landscape as everything is seen through
a film of atmosphere, and everything is influenced
by the colour of the things around it.

LAYING OUT YOUR PALETTE

You should try to get into the habit of always laying
out the colours in the same order. As you get to
know the layout, you will be able to go straight to a
particular colour without searching for it or picking
up the wrong paint by mistake. You can put the
colours in any order, but light to dark, starting on
the right, is a good way because it emphasizes the
tonal relationships of the colours you are using.

Squeeze out a generous amount of paint - more
than you think you will need. Don't be mean with
the paint, because you will find you haven't mixed
up enough of a colour and you will have difficulty in
trying to match the colours you have already put on.

FISHING

(17 x 25 cm/7 x 10 in)

Although this was painted on a dull day, there was still a lot of colour in the scene. You do not need to have a bright day in order to see strong colours. The green in the foreground was a quite intense colour, as was the rich darkish green in the water, which was influenced by the dark of the overhanging tree, and threw up the lights around it. Patches of earth along the bank that caught the light have been painted in a quite strong, light pink and set off the greens.

SEPTEMBER EVENING, BRIGHTON SEAFRONT

(15 x 20 cm/6 x 8 in)

The light shining on the water has been treated as a strong, warm colour. A warm burnt sienna or yellow ochre was used in the underpainting under the area of bright light, making the light yellow scumbled over it appear warmer. On the far side of the kiosk, the underside is picking up reflected light from the warmth of the sun. The warm colour in the foreground is picking up highlights from the sun, and the cool colour on the pier in the distance is throwing up the warm water.

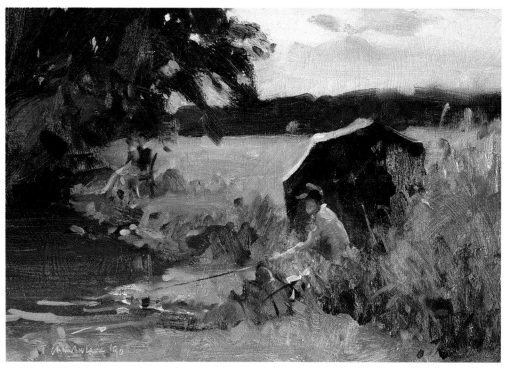

KEEPING COLOURS CLEAN

Try to mix the hues you want from two colours if possible, three at the most. Be wary of mixing hues from four colours, because you can easily lose any life in the mixture.

You can mix all your colours with a palette knife, which will help to keep mixtures clean. If you use a brush, clean it as you mix different colours by dipping it in turps/white spirits and wiping it thoroughly on a rag. If you keep dipping a brush into different colours without cleaning it, the previous colours will work their way out of the bristles and into the new mixture, creating dirty colours. For this reason, some painters use a separate set of brushes for different colour groups. Sometimes, however, you may want to mix a little 'mud' into a colour to tone it down and create unity among the colours you are putting on the canvas.

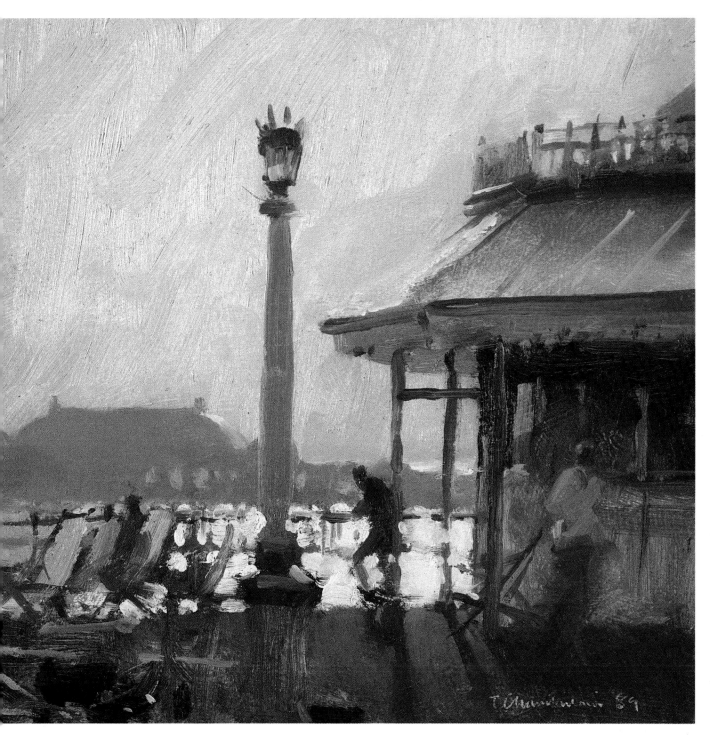

LOOKING AT COLOURS

When you are painting foliage, water, shadow or snow, for example, you need to look into them closely in order to decide which colours are really there. Greys, in particular, are difficult to see, and it takes time to train your eye to identify them. There are always several colours in shadow areas, and when you find them you need to accentuate them.

Be aware that although you know what colour something is - its 'local' colour - everything is picking up and reflecting colours from the other objects around it, and from the sky. Even with experience it is not possible to say, for example, what colour a shadow cutting across a patch of grass should be because it varies in different conditions.

If you have difficulty deciding on the tone or colour of an area in the scene you are painting, choose another area in the scene, and glance quickly

backwards and forwards between the two. In difficult cases this can help you to determine the correct colour to use.

COLOUR AND LIGHT

Light is always a colour, and you should use colour to establish the type of light or time of day in a particular scene. For example, if there is a passage of light reflecting off water, rather than painting it white you should put a stronger, luminous, thin colour underneath, and scumble over the top with a light tone.

The colour used for the underpainting should be a lightish tone, but should have a positive colour, and could be either warm or cool. Experiment with this, because it depends on the conditions. The colour scumbled over the top should be very light-toned and slightly warm - unless conditions dictate that a cool colour should be put over the top.

SEASONAL COLOURS

Winter is quite a colourful season. On a bright day in a landscape that has atmosphere and distance, a whole range of colours is present, such as oranges, purples and violets, and often they are quite strong. In autumn there is a lot of colour, but try not to overstate this because it is easy to go over the top. You will create a much better effect with a few bare trees and a splash of strong colour here and there. Similarly, in spring, when there are lots of greens, choose a subject that does not have too much green in it, so that the painting is not overwhelmed with passive greens.

WARM AND COOL COLOURS

Although it can be said in general terms that some colours are warmer than others, that, for example, reds and yellows are warmer than blues, the assessment of a warm/cool contrast is relative.

For practical purposes, the important point about the warm/cool relationship is that a colour only looks warm (or cool) in contrast to the colour next to it. If you want a colour to glow with warmth in order to reflect the quality of the light or atmosphere of a particular day, it is important to put areas of a cooler colour nearby to set it off.

Warm colours tend to advance and cool colours recede, but again only if they are next to cooler or warmer colours respectively. The warm/cool relationship can therefore be used to create space and depth in different areas of a painting, and for modelling solid forms.

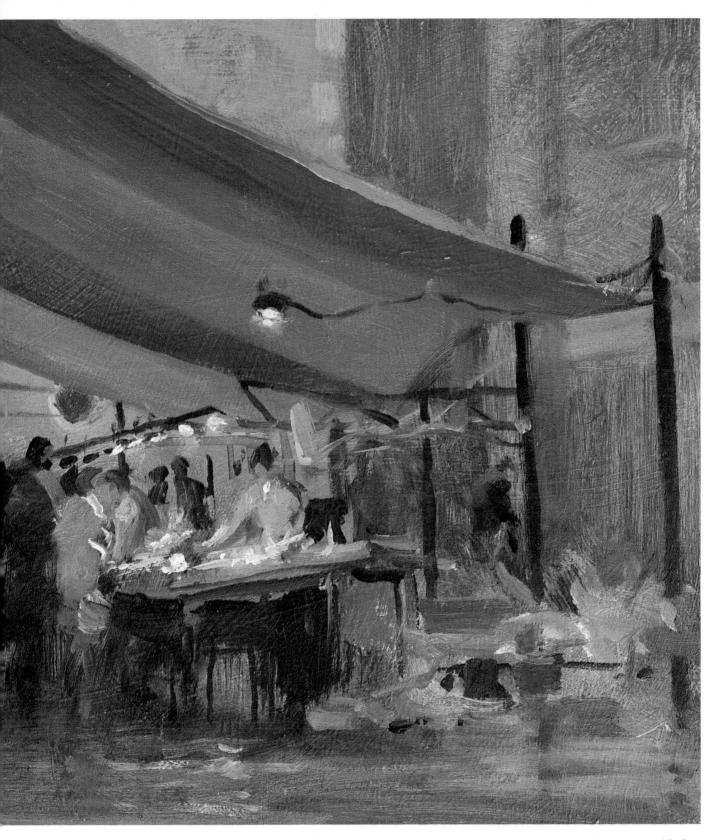

AWNING, VENICE FISH MARKET (17 x 25 cm/7 x 10 in)
The awning almost created the effect of being indoors. The deep shadows and dark, cool figures to the left of centre are just shapes, contrasting well with the warmth of the lights and people under the awning on the right. The awning itself has been treated as big slabs of bright colour. The artificial lighting, which creates a warm light and is reflected in the

warm-coloured, wet floor in the foreground, contrasts with the cooler light on the right that is being picked up from the sky. The floor is picking up colour in the foreground.

Touches of red have been used in the dark, cool area on the far right to set off the green. On the left, the subsidiary area of artificially lit stalls has been played down so that it does not distract from the main centre of interest.

THE ELEMENTS

Whatever subject you are painting, whether a stormy sky, rough sea, a peaceful winter landscape or people in a busy street scene, you can use the same approach. Rough them in as simple shapes, and then work over the top to distinguish forms, adding definition and emphasis in some places and understating other areas.

A little knowledge of your subject matter, together with careful observation, are the keys to creating convincing pictures. Keep on experimenting with different ways of applying the paint to prevent your work becoming too stylized.

DAWN FROST, HERTFORD
(25 x 35 cm/10 x 14 in)
This was painted just after dawn on a cold winter's morning. The scene contained many different elements - water, foliage, buildings, open fields - but all are unified by the early-morning light, the echoing of brush and knife marks and areas of softening throughout the canvas, and the harmonious colours produced by using a limited palette.

55

Skies

The sky dictates the mood of a painting, and other elements should be related to it. If the sky is bright, the whole scene will be bright; if the sky is broken, the scene will be patterned with cloud shadow; if the sky is overcast, the light on the ground will be muted. You can easily see the influence of the sky by looking at water. If the sky is plain blue, a strong blue reflection occurs in the water, whether it is choppy or calm. If the sky is cloudy and sunless, greys and greens will be reflected in the water.

Nothing in the sky is solid - it is just air and vapour. The light shines through clouds, and even the most obvious ones are superficial forms.

LIGHT SOURCE

Be aware of the direction from which the light is coming. If it's coming from the left, the right-hand side and underside of any clouds will be in shadow, and vice versa. If you are looking at a cloudscape that is lit from behind you, you will see a lot of light-coloured cloud shapes, with the sun reflecting off them - provided that there aren't so many clouds that you only get a glint here and there.

If you are looking into the sun, the light appears from behind the clouds. It may shine through the clouds, and can often be seen round the edges. The light will seem quite warm compared to the clouds in shadow. You need to spend some time studying different types of skies and sketching them.

WELSH COCKLE-GATHERERS

(25 x 35 cm/10 x 14 in)

The dramatic sky was bearing down on the estuary, and a little light was filtering through some of the clouds. In the distance the cloud and mist were so heavy that the distant hills merged with them and were lost. A patch of light on the sand forms the lightest part of the picture, echoing colours in the sky and helping to throw up the darkness of the sky.

The whole picture was quite heavily worked with the knife and the sky colours were softened with a finger. The sky was done in layers, starting with the furthest part. The next layer moving forwards overlaps it, and the highest part of the sky overlaps that. Quite a lot of the canvas texture shows through from wiping and scraping back, which helps to break up the sky and adds surface texture.

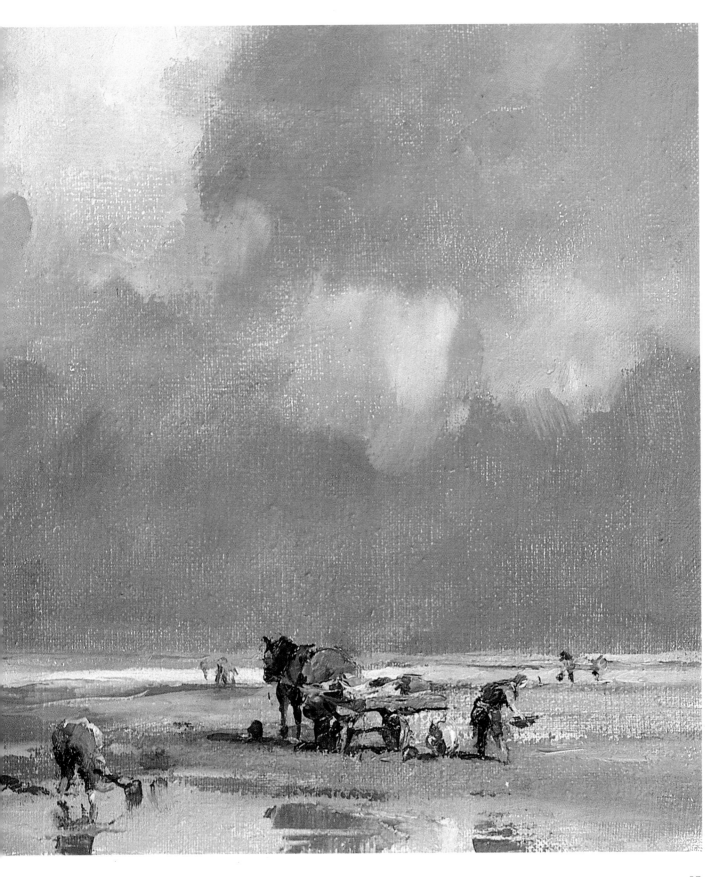

CLOUDS

The sky recedes just as the land does, and you need to be aware of the effects of perspective in clouds. They get smaller as they get further away, and some are partly obscured by others. Very often, there are several layers of different types of cloud, one above another. It is helpful to be able to distinguish between the different types of clouds.

Overhead clouds often look like a random mass. As they move away, their forms become more obvious, and in some conditions they flatten out on the underside in the distance.

CLOUD SHADOWS

Shadows are cast on to the ground in relation to the position of the clouds overhead. When putting cloud shadows into a painting, they must be logical in relation to the light source. You can get away with not relating them to the light source too closely, but you must remember that if there is a cloud shadow, there must be a cloud somewhere.

SUMMERTIME, BUDLEIGH SALTERTON
(60 x 75 cm/24 x 30 in)
The clouds were casting quite strong shadows over the landscape and sea, particularly in the foreground, concentrating attention on the lit, mid-distance area. The tops of the clouds were light because they picked up the sun, which was behind them. Touches of yellow ochre have been used to create warm areas where the sun shone through the less dense clouds. The denser areas of cloud have been treated as dark shapes.

When you are painting this kind of sky, aim to capture the arrangement of the clouds where you want them in the underpainting. You can then make adjustments when you work over them. Use light-toned, warm and cool colours, and take some of the paint off with a rag to lighten the background.

In most parts of the sky the edges have been blended, but a few definite edges have been made to suggest that those clouds are floating quite a long way forward of the sky behind.

58

RAINY DAY, ST IVES
(17 x 25 cm/7 x 10 in)
The sky, which was part stormy and part sunny, is reflected in the landscape with its pattern of strong sunlight and shadow running through it. The wispy clouds on the left have been made with quick marks, and show the light catching the clouds. On the right, the sky has been blended to create the diffused effect of the rain.

LOW COASTAL CLOUD, SUFFOLK
(50 x 62 cm/20 x 25 in)
A low coastal mist was rolling in from the sea. Because of the misty atmosphere, the clouds don't have much form, but they have been treated with subtle changes in tone and colour. This was painted with the basic sky palette, and blended extensively to create a soft effect.

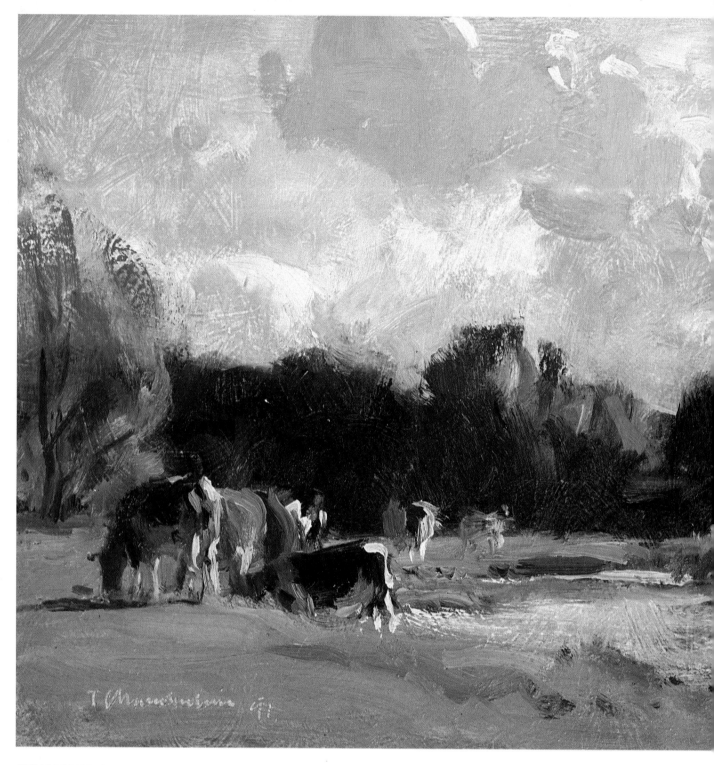

CHANGING SKIES

Skies change and develop through the day, and even from hour to hour, as can be seen in the three paintings of the Hungarian State Circus on pages 47-49. In settled conditions, the early morning sky is very soft and calm, and any clouds tend to be wispy and strung out. Towards midday the atmosphere becomes more turbulent and banks of bubbly clouds build up. Then, as the afternoon wears on, the atmosphere settles down and the sky tends to become cloudless again.

The problem is deciding at what point to fix the sky when it's changing all the time. When you have settled on your compositional arrangement - for example, an S shape continuing up into the sky - place the clouds according to that. Select the elements you want to include, and refer back to the sky while you paint them but don't keep trying to change your painting to suit the changing patterns of moving clouds.

WINDY DAY BY THE RIVER BEANE
(15 x 20 cm/6 x 8 in)

Left, this was painted on a very bright, quickly changing day, with the clouds coming over and disappearing again in rapid succession. The cloud forms are obvious but not overstated in order to keep an airy, fleeting feeling. A variety of warm and cool greys have been used in the sky, together with some highlights where the light coming from the right catches the tops and sides of the clouds. They have been painted with urgent staccato marks to convey the feeling of movement. The darks in the trees help to throw up the light in the sky.

END OF A DAMP DAY, WOOLWICH REACH
(15 x 20 cm/6 x 8 in)

Here the cloud was just beginning to clear and there was a hint of light being picked up by the cloud next to the little patch of blue sky. In this kind of subject, it is important to see the sky as a series of flat shapes rather than three-dimensional forms.

The clouds were unstructured, but were just beginning to break up and develop a little edge, and loose, lively brushmarks have been used to suggest this. The usual colours have been used, and the sky was given an overall pink tinge, which it tends to have at the end of a rainy day.

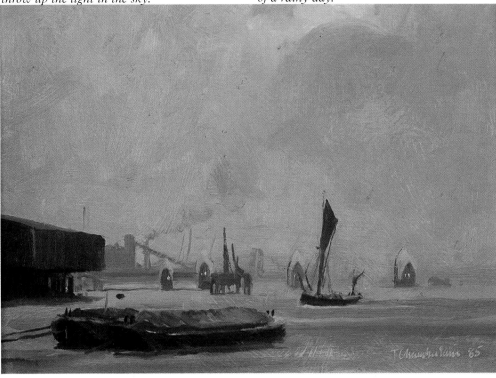

PAINTING THE SKY

Most skies contain a range of colours, and you should use about four - yellow ochre, burnt sienna, cobalt blue and a small amount of alizarin crimson near the horizon (see the sample sky on page 65) - plus white to mix the colours and tones that you want. You may see a touch of viridian here and there, but there won't be very much. Apply the colours in small patches, softening them with the finger but not blending them too much. If the sky is very dramatic and you need to add some real strength to the colours, you could introduce a little burnt or raw umber, but only in small amounts so that you do not deaden the overall effect.

First of all, establish what kind of sky it is: still, clear, hazy, moving, warm or cold. Once you know which you want to portray, rough it in as quickly as you can with thin paint.

With a plain sky, the temptation is to think that it is the same throughout. However, if you look at it

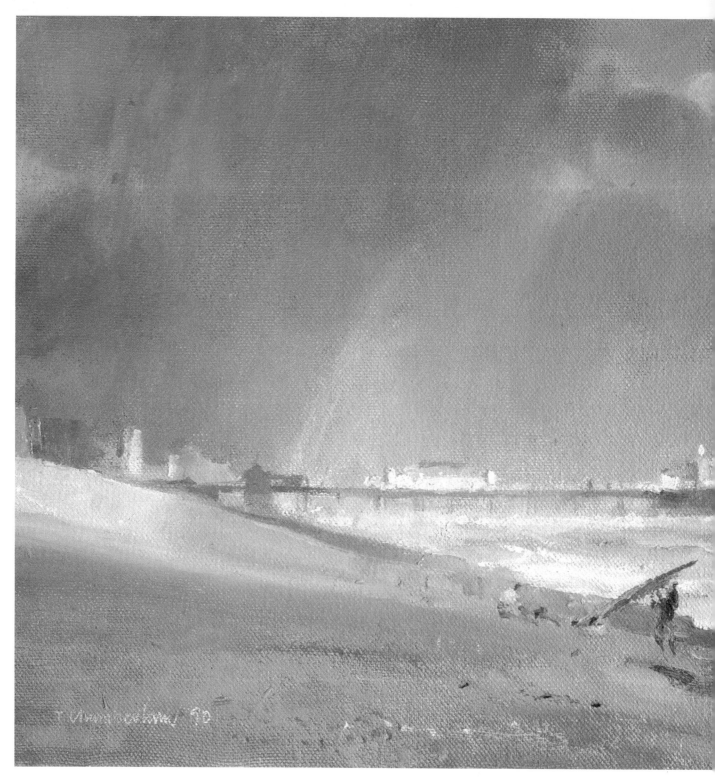

with your head on one side, you will see that the tone and colour change from top to bottom, and this is particularly evident towards the horizon.

Once you have completed the underpainting, which must show some regard to what you see, start at the horizon and try to pitch the right tone and colour just above it. Work forwards from the horizon, concentrating on pitching the tones and colours about right, adding the cloud forms, and

also putting in the tone and colour of the sky at the highest point accurately, so that you've got something to work up to.

RAINBOWS

A dark sky is needed to throw up the colours of a rainbow, and you only ever see them when the sun is more or less behind you. Rainbows are made up of seven colours - red, orange, yellow, green, blue,

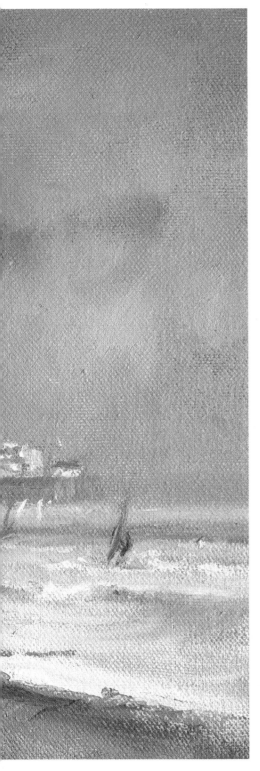

RAINBOW, BRIGHTON FORESHORE
(25 x 35 cm/10 x 14 in)
Left, in this scene, the sky was changing fast and it had to be arrested and held in the mind. Some knowledge of the colours in a rainbow and the effect they have on the sky is needed to paint them convincingly. The building and sea were painted light in tone to show up the dark passage of sky.

The clouds didn't have much form, but have been given some sort of shape. They were ragged because they were water-laden and raining here and there. This has been suggested by painting them with broad, loose strokes and using a variety of colours that have been softened to create a diffused effect.

At the bottom of the rainbow a small section of the pier has been put into cloud shadow to contrast with the rainbow. The cloud shadow in the foreground takes in the people and windsurfers so that they are not too obvious.

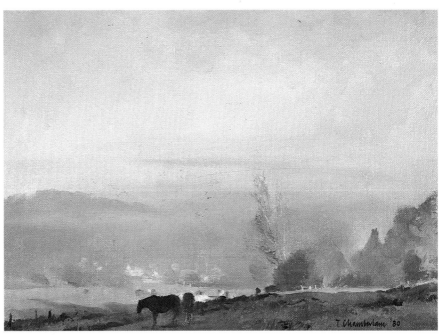

indigo and violet - but you are only aware of two or three when you glance at a rainbow. Note that the red edge is always on the upper side of the arch and the violet on the underside. Often the sky is lighter in tone under the arch than above it, and sometimes there is a secondary, much weaker rainbow. The secret is not to overpaint a rainbow; suggest it, or include only part of it, and keep it light and airy - see *Rainbow, Brighton Foreshore* (above).

FIRST LIGHT, WATERFORD MARSH (25 x 35 cm/10 x 14 in)
This sky is typical of very early, autumn mornings. It was still and slightly damp, and the mist was beginning to rise. One or two layers were forming in the sky, but these were quite light layers building up from the mist, not heavy cloud. Where the mist had cleared a little, glimmers of the early sun could just be seen. The sky has been treated as very translucent, especially in the higher parts, and there is a warm underpainting under the blue to make it sing.

Practice

Copy the two samples to get used to creating cloud forms and a sense of space in the sky. Experiment with the colour mixes suggested in the colour exercise, and see how far you can push the colours and still get a convincing effect. Take every opportunity to study and sketch different types of skies and cloud formations and the effects of different weather conditions.

MONOCHROME SKY

(15 x 20 cm/6 x 8 in)

Study the tones and forms of the sky in this example, the way in which the sky recedes and its relationship to the landscape, and then make a copy. This was painted using a neutral colour comprising burnt sienna and prussian blue plus white.

The foremost cloud is dark on the underside, medium-toned on the sides and light on top to create a three-dimensional effect. The sun is coming over the viewer's right shoulder, casting shadows on the left of the clouds. All the edges are soft, even those around the dark areas. The strength of the clouds can be seen in the largest one, which has the darkest darks and the lightest lights. Receding through the picture, the two extremes draw closer together.

DO'S AND DON'TS

Do note the direction of the light source.

Do make clouds smaller as they recede into the distance.

Do look for patterns made by cloud shadows.

Do decide on the arrangement for the sky and then keep to it.

Do apply the sky colours in small patches of paint, and blend a little but not too much.

Do start at the horizon and work up to the top of the sky when painting it.

Don't use pure white in skies.

Don't keep trying to change the painting as the sky changes.

Don't paint the whole sky with one strength of colour. The colour becomes weaker as it recedes towards the horizon.

SKY COLOURS (15 x 20 cm/6 x 8 in)

Cloud highlights: white and yellow ochre - highlights are not pure white, although they may look white if they are next to darker tones.

Cloud cools: white, yellow ochre and cobalt blue - use for shadows, but not the darkest areas.

Cloud warms: white, yellow ochre and burnt sienna.

At the horizon: white, burnt sienna, cobalt blue and alizarin crimson but use the alizarin crimson with discretion.

Cloud undersides: white, cobalt blue and burnt sienna - use for the darkest shadow areas.

Top of sky: white, cobalt blue and burnt sienna - use for the highest part of the sky, and lighten in tone as it recedes into the distance.

Darkest tone: cobalt blue and burnt sienna - used here for silhouettes on the skyline.

Water

The most important features when painting water are the surface reflections and shadows, and it is important to understand how these work. In still and running water it is reasonably straightforward, but it becomes more complicated when the surface is broken. Reflections are also influenced by the colour of the water.

In order to create a sense of depth you need to establish the different planes of the surface, mid-depth and at the bottom, and this can be done by setting areas of surface reflections and shadows against areas of light on the bottom. Surface shadows that enter the water, weed and even fish can all help to produce an impression of depth in clear water.

REFLECTIONS

If water is still, the reflections are mirror-images of the things round about, and their portrayal is quite straightforward. The important point to remember is that objects seen in water are not as intense as the source of the reflections: skies are a little duller, darks are slightly lighter and colours are muted.

Reflections have their own shapes, and echo the shape of what is reflected. Try to simplify these shapes, half-closing your eyes if necessary to cut out detail. Also, look for any changes in large shapes from front to back as these will help you to convey a sense of recession.

Reflections have perspective. Imagine that you are looking at a building on the opposite bank of a river. The reflection starts at a point under the front of the building that is on the same plane as the water surface, and extends forwards from there. The reflection of the base of the building does not fall at the water's edge, so you do not see the whole of what is reflected. The amount you do see is in direct

PATTERN OF SHADOWS, DICKER MILL
(50 x 35 cm/20 x 14 in)
Right, the pattern made by the shadows on the water surface formed the subject. The alternation between light and dark patches that is such a strong feature on the water is echoed in the background foliage.

In the detail below left, the moving water near the weir is picking up the sky colour against dark reflections, and the broken water surface is suggested with short, patchy marks.

In the detail below, the patches of light blue sky reflection establish the plane of the surface of the water. The cool edges on the nearer sides of the shadows make them look as if they are penetrating the water, and the warm edges sit on the surface.

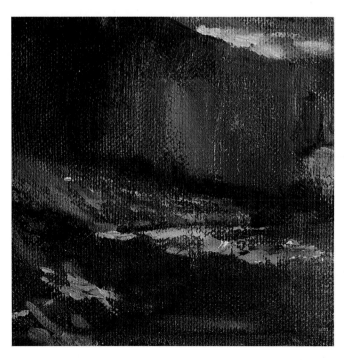

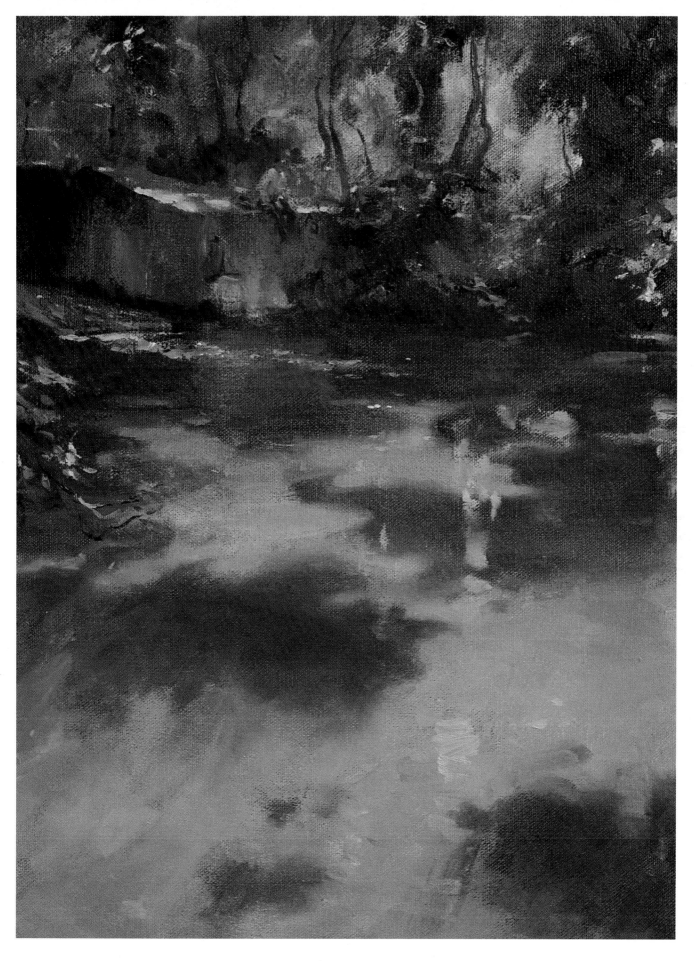

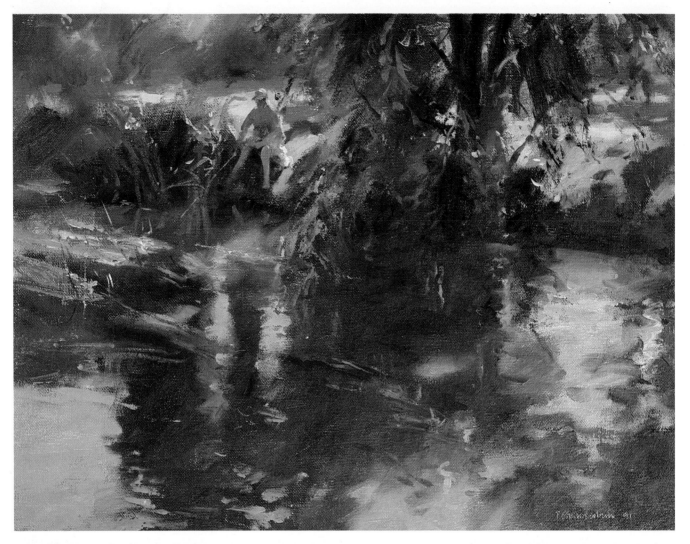

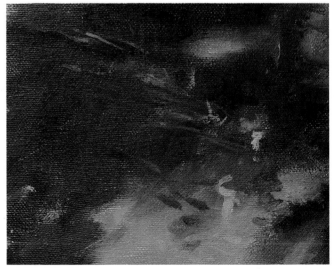

THE NOVICE (35 x 45 cm/14 x 18 in)
This complex painting illustrates all the aspects of painting water.

The light-toned area under the far bank is reflecting light from the sky, but being further away has less colour in it than the nearer reflections.

Several levels have been suggested in the water. The blue/grey reflections establish the plane of the water surface. There are shadows cast by the tree on the far bank, against patches of light on the bottom, creating a sense of depth. Weeds sticking up above the water's surface catch the light, and there are also weeds and fish at mid-depth.

MORNING, NEW RIVER AT
WARE (17 x 25 cm/7 x 10 in)
*The reflections were muted in
tone and colour compared to
the objects they were
reflecting, but because the
water was very still, the
shapes are quite faithful to
their originals. The reflections
are positioned immediately
below the objects casting
them, and the effect of
perspective can be seen in
that only the upper parts of
the buildings are visible in the
water. Shapes have been kept
simple, and some are lost
altogether. The paint has
been kept thin for the water,
which creates the glassy
effect. The reflections have
been painted with vertical
brushstrokes, as these are the
most convincing.*

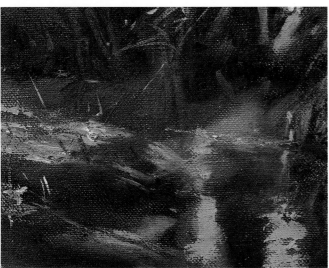

*The darks were painted first, with the lights put on over them.
The lights were painted with thick opaque paint so that they sit
on the water surface. The reflections are vertical and directly
below the object casting them, which helps to convey the
flatness of the water surface.*

relation to the distance that the building, tree or
whatever, is set back from the water's edge. See
Mellow Autumn, River Beane (page 74) for a good
example of this.

Reflections can occur in running water, but they
are distorted, and are greatly influenced by the sky,
surface eddies and so on.

Reflections are darker nearer to you and lighter
further away. This is because, when you are looking
into the distance, you see water at a flat angle, and
therefore you see more of the influence from the sky.
When you are looking down into water, colours and
tones are more obvious.

BROKEN SURFACE

Where the surface of the water is ruffled, for
example where a shallow stream is running over
pebbles or a stretch of water is being roughed up by
the wind, the reflections are less straightforward.
Usually, the surface in the distance is lighter,
because you are seeing it influenced by the sky.
However, in certain cases darker patches of water

UNDER THE TREES, RIVER RIB (17 x 25 cm/7 x 10 in)

Left and below, the small patches of sky reflection and the sunlight on the river bed establish the surface and depth of the water. The river has been painted very thinly, except for the sky reflections, which have been stated with thick, opaque paint. The shadow areas have been thinly stated. In one place, the blue underpainting shines through the over-layer of deep violet. The plants in the bottom right-hand corner were done with quick flicks of the brush.

FRED'S FLEET (17 x 25 cm/7 x 10 in)

The water in the background has been painted with vertical brushstrokes, and the horizontal band of light behind the boats was scumbled to indicate the broken surface of the water. The water is influencing the tone and colour of the boats themselves. The left-hand side of the boat on the left is reflecting a cool blue from the water, whereas the right-hand side is picking up warmth from the boat on the right. Warm and cool colours in front of the boats create the gentle ripples.

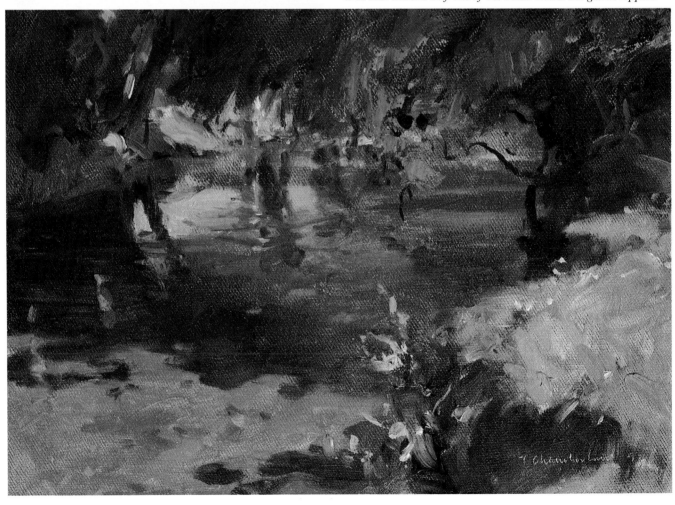

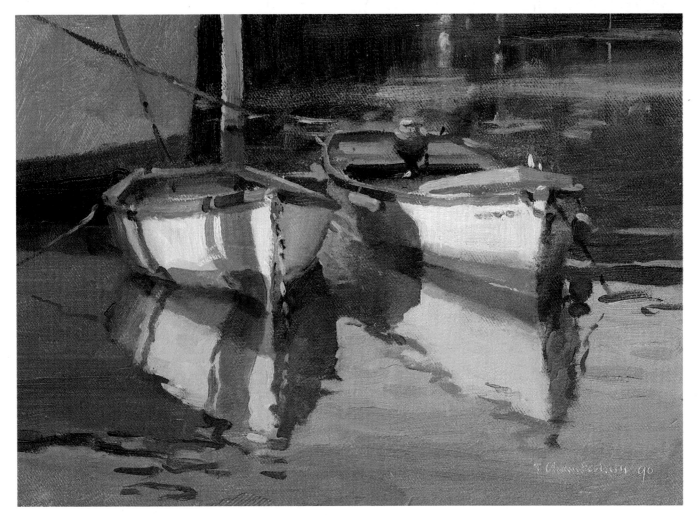

occur both near to and in the distance because shadows are being created by ripples and choppy waves, giving a general, overall dark effect. Remember that you are looking at a broken surface, not a continuous plane of colour.

With very choppy water, you are generally more aware of its surface than the things reflected in it. However, some reflection occurs even here, but it is very fragmented. Small brushmarks are best for creating the effect of a broken surface.

COLOUR
On still water, the colours are influenced by the sky and by reflections, but all the colours are muted. On running or ruffled water, colours are broken. In rough water, also, debris is being churned up from the bottom, and ochres and greens come into play.

SHADOWS
Shadows, cast by clouds or overhanging foliage, are generally seen as soft-edged areas. On clear water they are almost non-existent on the surface, whereas on cloudy or coloured water they can be very obvious. However, shadows do not occur just on the surface. Notice the way they penetrate the water, and can sometimes be seen on the bottom in very clear water. Also, the shadows on the bottom do not necessarily coincide with those on the surface because of the angle of sunlight. Look for the cool and warm parts of each shadow. As they penetrate the water they show up differently - see *Pattern of Shadows, Dicker Mill* on page 66.

THE SEA
The sea is quite a difficult subject, and the most successful sea painters are those who have studied it for years. Try to establish whether the sky will change much while you are painting, because if it does it will alter the whole character of the sea.

The sea is a very open expanse of water and is greatly influenced by the moods of the sky and weather. Because of the clarity of the water, shadows may be seen on the bottom more than on the surface. And if the surface is rough, it will be picking up colours and tones from the things around. Because it is constantly moving, the water is loaded with grit, sand and other debris, and you can see colours from these particles.

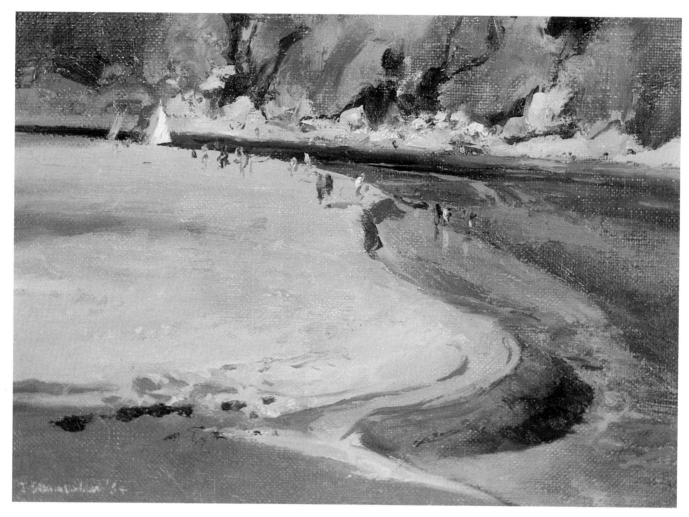

EDGE OF A SANDBANK (17 x 25 cm/7 x 10 in)
The sandbank, especially in the foreground, shows the effect of reflected lights in the shadow area. The paint was used thin for the sandbank and thick for the central channel of water, the reflected light and the rocks in the background. The caverns and depressions in the rocks in the distance were understated so as not to distract attention from the main area of interest.

CRISP CORNISH LIGHT (45 x 60 cm/18 x 24 in)
Top right, the sea appeared quite dark in the distance because it was rough and in shadow, and was picking up a lot of blue from the sky. It became greener as it approached the beach, where the breakers were coming over the sand in sunlight, and the particles in the sea were being picked up by the light. In the foreground there was wet sand, some of which was in shadow and some in sunlight, reflecting the sky.

The stonework on the left, which was submerged at high tide, was covered with lichen and showed as rich greens, browns, red and ochres. A few construction courses have been indicated in the stonework.

The atmosphere out to sea tends to be hazy and you often don't see the horizon line; sea and sky merge into each other in the distance. Even on a very clear day when the horizon is visible, you should avoid indicating it as a hard line. The surface of the earth is curving away at the horizon and a hard edge between sea and sky looks unnatural.

Cloud shadows are very obvious on the sea, and are useful for breaking up a large expanse of water, as can be seen in *Shipping off Falmouth* (page 2).

Boats on a rough sea do not sit in one position. They toss, roll and heave in different directions, and by positioning them at slight angles you can give a feeling of movement to the water.

BREAKERS AND BEACHES

Breakers have a definite form, which is revealed through areas of dark and light. Look for the deep shadows under the crest of a wave, and the way the

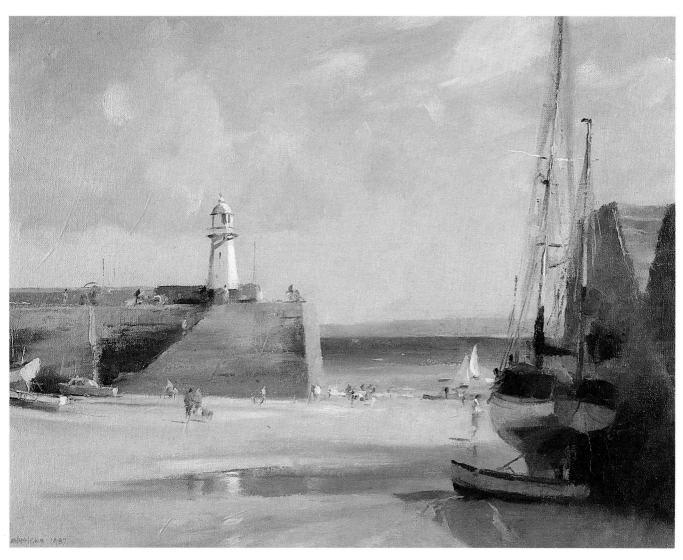

light catches the top of the wave, especially as it breaks and tumbles over itself. As the water comes foaming up the beach, several colours and tones are evident.

Good examples of breakers can be seen in *Rainbow, Brighton Foreshore* (page 63) and *Morning Air, West Pier, Brighton* (page 101). The structure is indicated, but the breakers are not portrayed in detail. The tops are light, and there is a dark rim where the tops curl over. The body of the breakers is a mid-tone. They flatten out into foam as they run up the beach. Perspective can be seen in the lines of breakers, which converge towards the pier and are reduced in size as they get further away.

Look for the effects of water on the sand as the waves recede again. Water sinks into the sand as it runs up the beach. As it recedes, it leaves an area of wet sand, which reflects the sky and therefore appears very light in tone. As the sand dries out

slightly, and becomes damp rather than wet, it no longer reflects light and therefore appears to darken. Sand above the water line remains dry and is light in colour.

CLIFFS AND SEA WALLS

Study the structure of cliffs. Are they stratified? If so, which way do the strata run? And is there any vegetation? However, don't paint in all this detail, just suggest it. In *Beach at Beer, Devon* (page 38), for example, only a few of the strata have been put in, and plants have been included here and there.

The same principle applies to stonework and other structures. Treat them as simple shapes. Look for changes in colour and tone and state them simply, then add a little detail to give character. Also make a note of the direction of the light, and of the lit and shadow sides, and any patches of glancing light cutting across them.

Practice

Water is a difficult subject, and to begin with you should limit yourself to uncomplicated subjects when you work on the spot: simple reflections on still water; a stretch of ruffled water; a stretch of fast-flowing water. Then try scenes that include cloud shadows or deep, clear water. When painting ripples, vary the shapes - don't just make a series of squiggles.

DO'S AND DON'TS

Do simplify the shapes of reflections.

Do study the perspective on reflections.

Do make the colours and tones in reflections weaker than those of the things causing them.

Don't paint ripples as a series of squiggles.

ON THE RIVER AT EPILUCHE (35 x 25 cm/14 x 10 in)
Right, the water was quite thick and clouded, so the tree shadows were showing up more strongly. The water was moving fast, with eddies breaking the surface and picking up the light. The boat has been made to sit in rather than on the water by losing the water line. If the water had been clearer, there would have been more reflections. However, even those from the boat were muted because the water was muddy. When copying this, try to develop brushmarks that convey the difference between the still and broken areas of water.

MELLOW AUTUMN, RIVER BEANE (25 x 35 cm/10 x 14 in)
Below, the reflections are light-toned and very simple in shape. The effect of perspective can be seen, as only the top halves of the trees are visible on the water. There is a slight ripple at the lower ends of the reflections where a little surface disturbance is picking up light. Copy this example using the basic palette, concentrating on stating the reflections very simply.

Marine

Marine subjects include harbours, tidal rivers, ships, docks and boatyards, canals and narrow boats. These scenes are often busy and cluttered, and need to be simplified. In *Barge at Erith* (page 36), for example, the barge has been reduced to a simple shape and the quayside has been treated as a silhouette.

Boats need to be drawn well, and must look as if they could float or are afloat to be convincing. All boats have their own character, and you should look for this in the shapes and lines of each one. The length of the boat must be right in proportion to the height and thickness of the mast. It is a good idea to build up a collection of sketches of boats, as you may need to work from them for a painting.

Rigging, even if it is bulky, should be simplified.

AGAINST THE TIDE, ROTHERHITHE
(17 x 25 cm/7 x 10 in)
Right, the boat was moored more or less in position, and movement was indicated in the water to look as if the boat were moving. This was done by building up the water at the front of the boat. The water line dips and rises again along the side of the boat, and churns at the back near the propeller.

SHOWERY DAY, RIVER ORWELL
(17 x 25 cm/7 x 10 in)
Sailing barges are majestic boats and it is very important to get the proportions right, so that they do not look stunted. The upper mast here is in the lowered position; it would be very tall when sailing. The late evening light is catching the front of the barge and shining into the water as reflection. The dinghy gives a sense of scale to the barge, and the rigging has been suggested with lost-and-found lines.

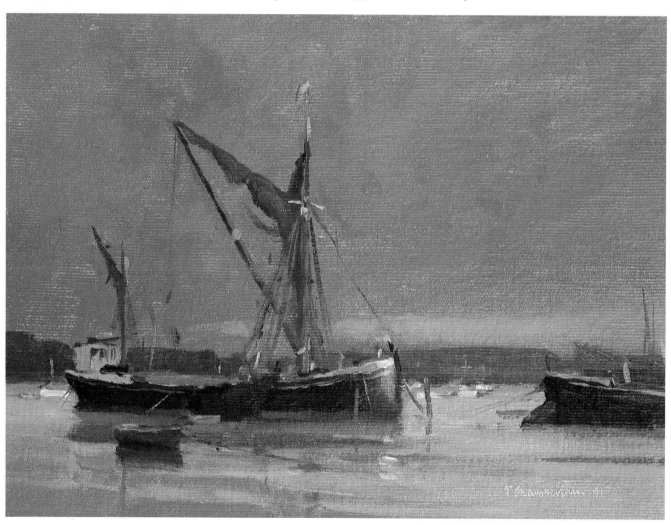

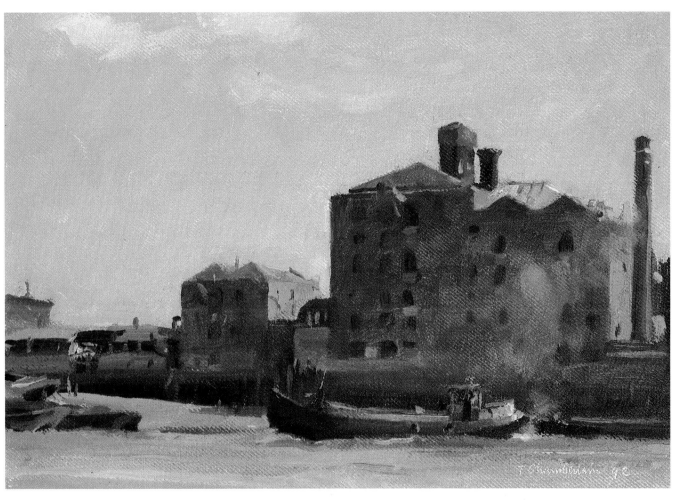

MIST CLEARING, TENBY
HARBOUR
(25 x 35 cm/10 x 14 in)
*The harbour was more
cluttered than appears here.
Groups of boats were selected
for inclusion, and the main
boat was positioned so that it
leads into the picture. A
feature was also made of the
foreground pool. Linear
perspective (see page 96) is
evident in the quay going
away on the left, and aerial
perspective between the steps
and the crane, receding back
to the buildings and shapes
on the distant hill.*

Two views of a ship being slowly drawn along by a tug. The upper sketch was done in two to three minutes, and conveys the sense of a ship looming up as it comes towards you. The lower one captures the line of the ship as it passes away downriver. In both, the midships are very simplified.

A New Zealander

These three sketches capture the changing angle of the sails on the approach, broadside on and moving away. The different outline at the front and back of the boat has also been observed.

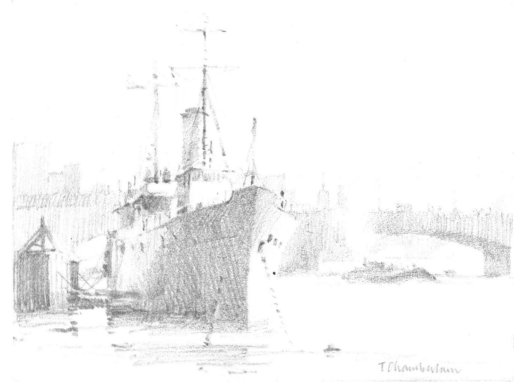

This is a very quick drawing, done with pen and felt-tipped pen, of a wharf with a couple of barges drawn up alongside at low water.

This is a more careful drawing that shows the relative tones in a scene, and provides enough information for a painting. The scene has been reduced to simple tonal shapes, but it includes quite a lot of detail in the ship.

T Chamberlain

Half-close your eyes in order to pick out the essential parts, and suggest these with broken lines.

When you are standing on ground that is level with the water, you will notice that you cannot see much distance between the water level along the side of a boat and that at the far bank. For this reason, you should set any boats in a picture quite a long way up towards the horizon. You can see this in *Against the Tide, Rotherhithe* (page 76) and *Shipping off Falmouth* (page 2).

When a boat is moving through water, look for the way that the water builds up against the front of the boat and the waterline dips and rises along its side. If the boat has a propeller, water will be churning around at the back of the boat and catching the light. You can take a boat moored in midstream as your subject, and by painting the water in this way make the boat look as if it is moving, as was done in *Against the Tide, Rotherhithe* (page 76). In *Autumn Afternoon, Lower Pool* (page 31), flowing water has been indicated with a wavy line along the side of the barge.

If there are a lot of cranes and other structures along the waterside, be selective and include only those that contribute to the composition. And remember that any buildings, such as warehouses, and quaysides are subject to the effects of linear perspective (see page 96).

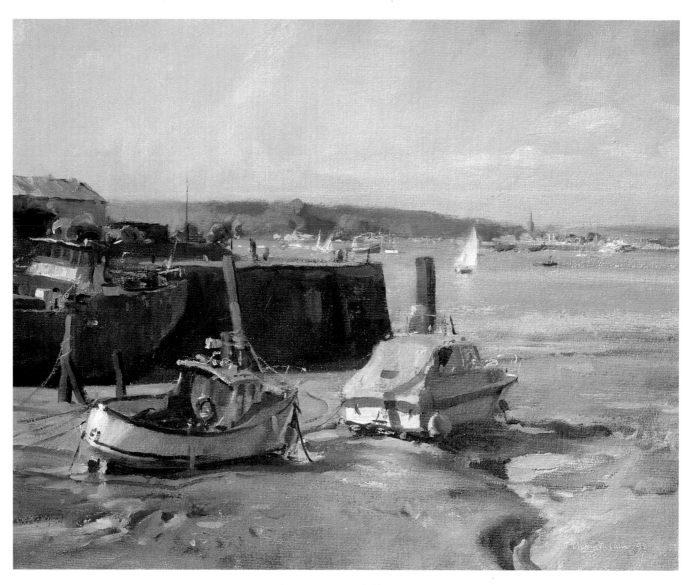

SAILING, RIVER BLYTH
(25 x 35 cm/10 x 14 in)
Right, the boats have been grouped on either side of the picture, and the heights of the masts have been varied. The main subject is the boat sailing up river, with the reflected light below it helping to focus the interest. A suggestion of moving water has been created by using lots of long, fluid brushstrokes.

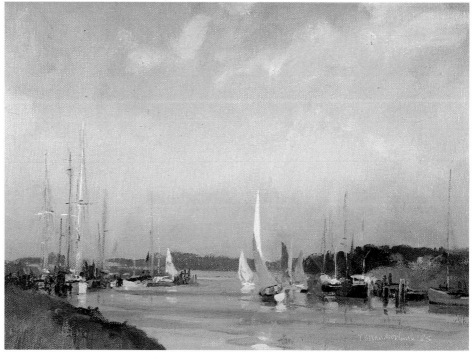

AFTERNOON IN SUMMER, GILLINGHAM PIER
(35 x 45 cm/14 x 18 in)

The foreshore is seen at low water, and there is a wealth of colours in the exposed sand. A variety of colours was used in the underpainting and allowed to shine through to make areas of light and shadow. Some areas are wet, creating reflection, and there are pools that give more obvious reflections.

There is no definite water line. You are aware of it mainly through a change in colour from the foreshore to the water.

The strong patch of light on the water in the nearer part of the sea was constantly shifting. In such a situation, the area catching the light can be placed where it best fits the composition. However, it shouldn't be placed completely out of context, but positioned within the general area where you have seen it. The sea has been painted over a warm underpainting and the light area was scumbled on.

The left-hand boat leaned to the right, whereas the right-hand boat sat squarely on the sand because it was flat-bottomed. There was an area of warm, subdued, reflected light on the inside of the left-hand boat because it was in an enclosed area and was picking up light from the cabin. The nearer side was in an open area and was picking up cool reflected light from the sky. The superstructure of both the boats has been reduced to flicks of paint and suggestions of detail. The front edge of the right-hand boat, against the sea, has been lost to let the eye do some of the work and prevent the picture from becoming too static.

Cool shadow areas have been put on over a warm underpainting. A patch of water is reflecting light from the sky and is in sharp contrast to the shadow end of the left-hand boat. A cast shadow across the back of the right-hand boat helps to suggest its contours. The bottom line of the two boats is lost in the shadows.

The quayside was in shadow, but a variety of surfaces, some shiny, some not, have been indicated. The number of timber posts was reduced, and their heights were altered, the one on the left being raised so that it broke the line of the top of the quay. The distant dinghies have been suggested quite roughly.

Depressions and humps in the foreshore have their own form. This gully (at the bottom edge of the picture) had cool shadow on one side, with an area of warm shadow at the bottom of that side where it was picking up warm colour from the opposite side, which was in sunlight.

Practice

You need to do lots of sketchbook work for marine subjects in order to become familiar with the outlines of different types of boats, and to help you pick out the wealth of other subjects found along water, such as people at work, quaysides with structures such as cranes, and general clutter.

The examples opposite of a dinghy from five different angles illustrate the curves and lines of the boat, and the extent to which the overall outline of the boat changes with different viewpoints. Seen from the front and back, the boat is much broader than you might think. Copy these examples, and then repeat on the spot with as many different boats as possible.

Copy these small sketches in order to see boats and people in simple terms, and collect your own examples in a sketchbook. These sketches have been done in watercolour, which is a good medium for making quick sketches and colour notes.

DO'S AND DON'TS

Do study the lines and shapes of different boats in order to capture their character.

Do make sure the mast is the correct height in relation to the length of the boat.

Do set boats high up towards the horizon.

Do observe the effects of perspective on quaysides and buildings.

Do try to capture the way the water rises and dips along the side of a moving boat.

Don't put in all the details of the rigging.

Don't include all the clutter along the waterside.

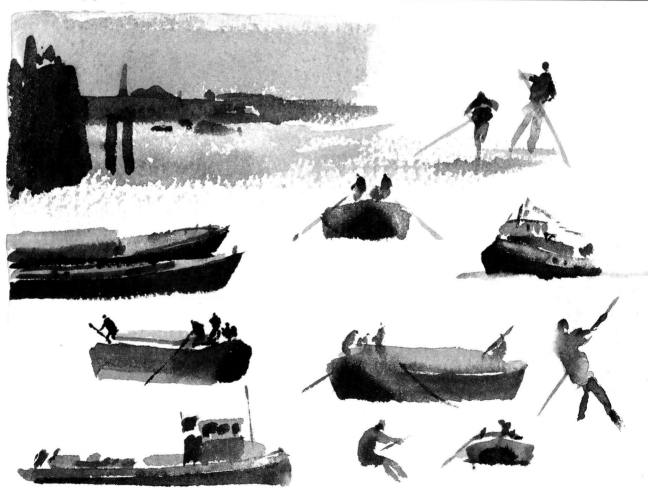

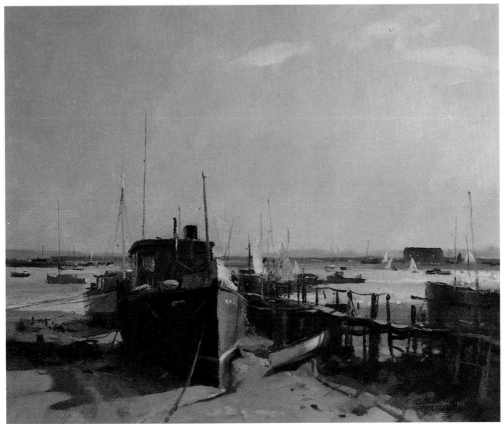

SUMMER LIGHT, WEST MERSEA
(40 x 50 cm/16 x 20 in)
This was a complicated scene with a lot of paraphernalia, especially in the bottom right-hand quarter, which has been suggested but not shown in detail. Sections of the balustrading have been left out. Make accurate sketches of different elements in the scene, studying the weight and quality of the lines used for the balustrading and rigging, and the overall pattern of light and dark shapes.

Trees and Landscapes

In some shape or form trees are a prominent part of any landscape. Unless they have been blown over, they are balanced on the trunk. Even the wind-blown hawthorn illustrated on page 92 has its weight quite evenly distributed over the base of the trunk. The pine tree illustrated on the same page has a trunk that leans to the right, but it has compensated for this in the upper part by growing to the left so that the canopy of needles is over the base of the trunk.

The overall shape of a tree should convey its character. The proportions, shape and type of foliage are the ways in which different species are recognized, and you need to be able to distinguish between them in your paintings. A selection of common species of trees is illustrated on page 92.

Simplify tree shapes. You can create a sense of volume by making the parts nearer you, which are picking up light, lighter against the dark main mass behind. Treat groups of trees as one overall shape initially, then suggest individual trees here and there with touches of a lighter tone where you see the light catching them.

Note the direction of the light, as this determines the warm and cool sides of a tree. The light side will be picking up warm colours, whereas the shadow side will be cool and will be picking up blue from the sky. If you are looking at a tree with the light behind it, the far side will be well lit with warm colours, which will show through in places around the edges of the dark central area.

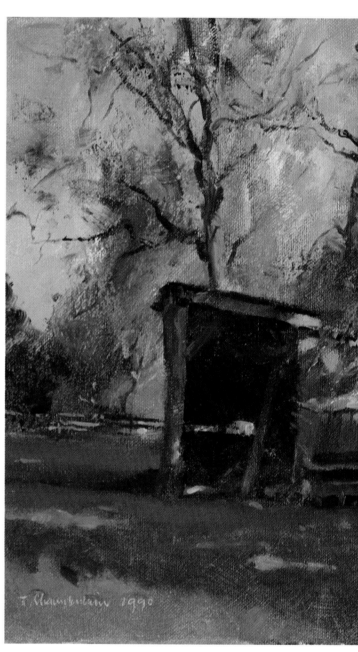

In this detail from the picture above, the background foliage has been created mainly in the underpainting, with alternating areas of cool shadow and warm light. Small touches of thick paint have been used for highlights. Some branches have been put in with lost-and-found lines.

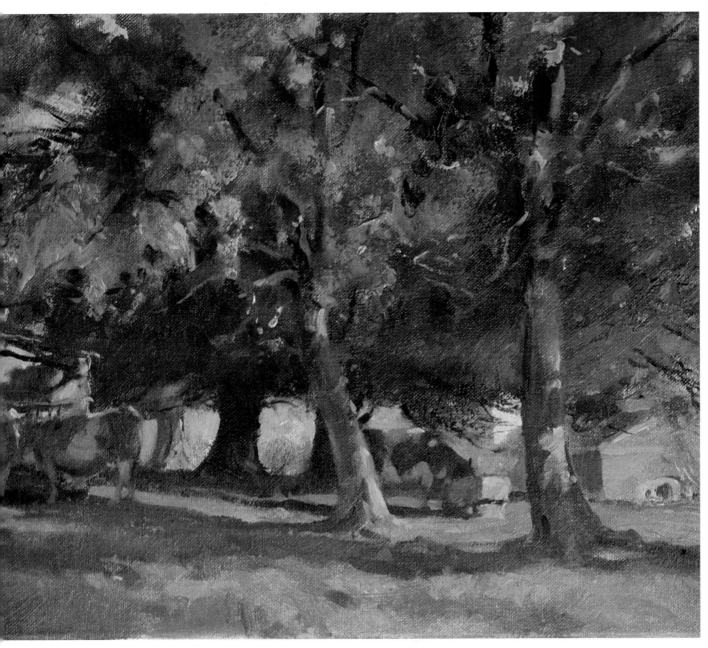

COWSHED AT WALKERN (30 x 60 cm/12 x 24 in)

This was seen as a mass of trees and foliage with the warm reflected light on the far right and the half-tones along the top suggesting some form. Some foliage was catching quite strong sunlight and was painted by dragging and scumbling quite thick paint over the underpainting. Both warm and cool colours have been used in the highlights.

The main mass gave way to the lit area behind the cowshed, which was picking up some warm sunlight, as was the bare tree behind it. Leaves have been brought down over

the front of the cowshed in a ragged way to break it up.

The dark underside of the foliage was scumbled with a palette knife to let hints of the landscape behind show through.

The tree trunks in the foreground were painted using several colours. The sense of roundness was created by the sunlight striking the right-hand side and the reflected light on the opposite side.

The sunlit patches on the ground have several colours in the underpainting, and have soft edges. They were painted mainly with a brush.

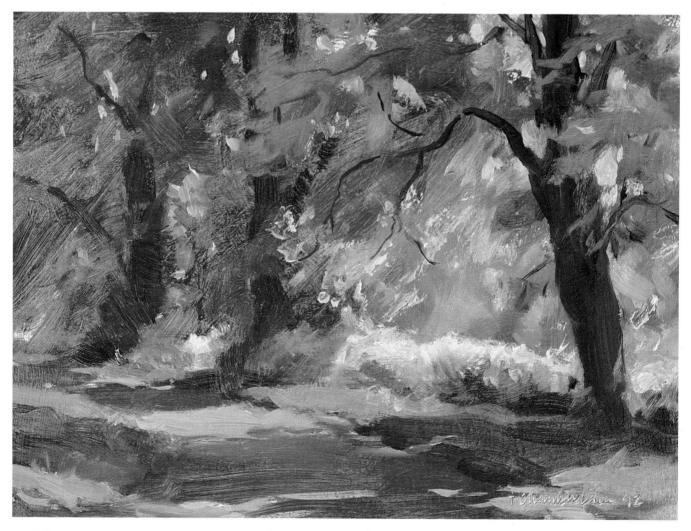

COW PARSLEY, GOLDINGS (15 x 20 cm/6 x 8 in)
This was painted on a bright day with the sunlight bursting through the trees. The liveliness and vigour of the day was captured in the way it was painted. A lot of the work was done in the first application of paint, using directional brushstrokes, which gives a feeling of energy and spontaneity. The highlights were then added with quick dabs of paint.

The trunks of the far trees were shrouded in undergrowth and were treated as a cool shadow area, whereas the right-hand tree was in a more open space and therefore picked up the warmer colours all around.

The pinky colour was seen in the cow parsley. In the foreground tree, the small patches of sky were added over the foliage.

Look at trees very carefully for colour. In spring and summer, greens are tempered by lots of other colours. Some trees may be beginning to turn; some may have some dead leaves in among the green ones. Look for the influences of surrounding objects on the colours in the foliage, and for cooler colours on the side away from the sun. Autumn colours can be very seductive, but beware of overstating them. As trees recede into the distance, the colours become more muted and simplified.

If a tree is in blossom, go for a suggestion of the colour, but do not try to paint the blossom in detail. In *Spring, Welwyn Garden City* (page 98) the tree is about to burst into flower, and this has been suggested with the use of pinks and ochres. The left-hand side is in shadow, and has been painted in a

SNOW IN THE ORCHARD (17 x 25 cm/7 x 10 in)
*Left, the sky was painted in a warm, light
tone. The paint was put on thinly with a
palette knife and partially scraped off again,
so that the crevices in the canvas showed.*

*The snow was painted over a warm
ground as the area was sunlit. A lot of warm
colours can be seen in snow because it
accentuates the warmth in grasses and
undergrowth.*

*The apple trees were treated as large
shapes, and a variety of colours were seen in
them, together with a hint of frost on the cool
side of the trees on the right. The trunks of
some of the trees on the far right were seen in
silhouette against a very light area, whereas
the other tree trunks were catching the light,
revealing their twisting forms.*

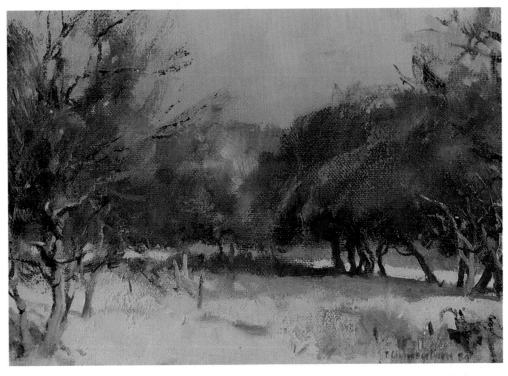

Detail from PATTERN OF
SHADOWS, DICKER MILL
(page 66)
*Below, the bright, warm
underpainting has been
allowed to show through in
several places to give the
impression of looking through
a densely wooded area to
sunlight beyond, and the
foliage has been treated
broadly. Small touches of
highlights have been put in
with the tip of a palette knife
and a brush.*

cooler version of the blossom colour, and a lot of
underpainting has been allowed to show through.

Tree trunks show a variety of colours. Because
they are cylindrical, they reflect light from all
directions. Highlights occur on the side facing the
sun, and on the opposite side they pick up reflected
light from the things next to them, or from the
ground. The higher part of the trunk will be darker,
because it is in the shadow of the branches, and the
lower section will be lighter. Another point to be
aware of is that moss grows only on the north-facing
side. Also notice the degree to which trunks spread
as they go into the ground. They are seldom straight
at the bottom. Look for places where trunks are seen
as light against a dark shadow area and accentuate
this.

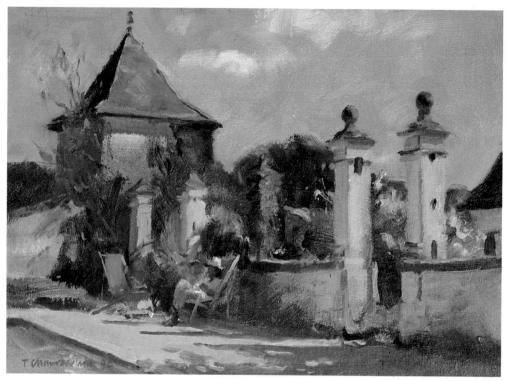

BY THE POOL, LUSSAC, FRANCE

(17 x 25 cm/7 x 10 in)

Above, the range of greens, yellows and browns and the wide variety of shapes in the foliage, together with the touches of bright red and yellow for flowers, suggest the diversity of colours and shapes found in a garden. Much of this was created in the underpainting, with dabs of bright colour and thicker paint for the flowers and highlights.

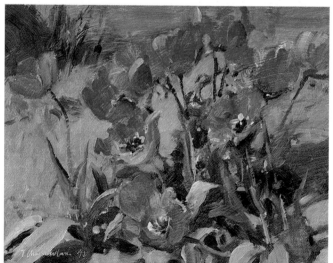
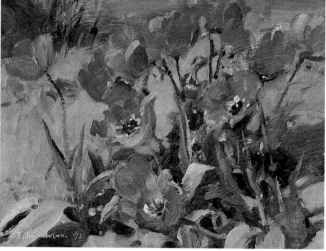

TULIPS IN THE SUN (15 x 20 cm/6 x 8 in)

An effective painting can be created by going in close rather than painting a whole scene. The colour of the tulips was very striking, and contrasted with the cool green of the leaves. The cool colours in the shadows make the tulips stand out, and only the flowers at the front of the group have been shown in any detail. A rhythmic pattern runs through the whole arrangement.

GUNNERA MANICATA (17 x 25 cm/7 x 10 in)

Above right, the light shining through the leaves of the Gunnera manicata *was a strong enough feature to form a study on its own. This impression has been created through the contrast with the darker areas around the leaves and their dark veins. The water-lily leaves and reflections give the pond surface flatness. The warmer browns and oranges emphasize the greens, and the cool green around the edges of the leaves show that they are picking up light from the sky.*

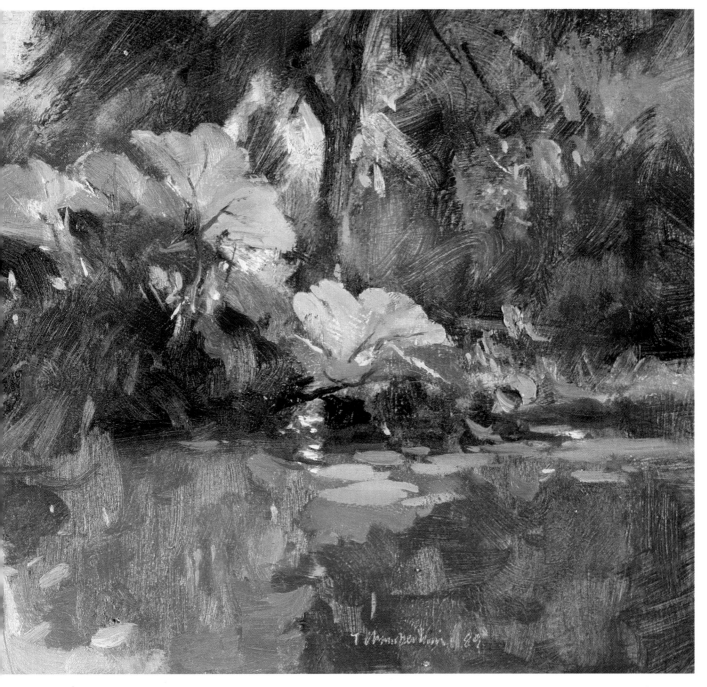

PAINTING FOLIAGE

Indicate individual trees and groups as part of the underpainting, putting in the darks roughly and quickly; see *Cow Parsley, Goldings* (page 86).

Don't try to paint twigs and small branches individually. Block them in with a large brush lightly loaded with paint. Then state the lighter areas using thicker paint. Finally use a palette knife or a heavily loaded brush for the highlights. To create the effect of small clusters of leaves picking up the light, choose a line to follow and keep your hand moving, twisting your wrist as you go to get some variety into the marks; see *Evening by the River at Kingston* (page 92). You can modify the highlights later if they

stand out too much. When you are painting foliage against the sky, put in little patches of sky after you have painted the foliage rather than trying to leave spaces.

In *In the Shadow of the V&A* (page 96) the foliage seen against the building has been roughed in at the underpainting stage and left. On the right, where a lot of twigs are seen against the sky, they have been very lightly stated with a broad brush so that they look fine and feathery, but they are not treated individually. In *The Circus at Noon* (page 48), where the tree was seen in silhouette, the structure has been simplified with just the trunk and a few of the main branches picked out clearly.

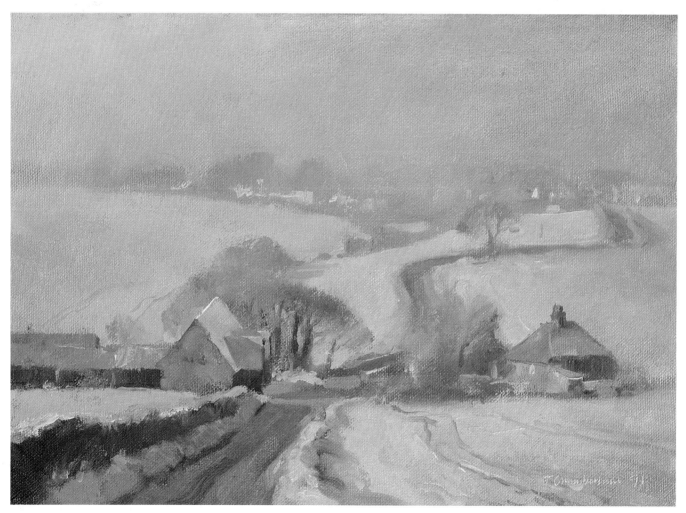

FROSTY FIELDS, ASTON (25 x 35 cm/10 x 14 in)

OPEN LANDSCAPE

When you are selecting from a large scene, home in on something in particular that interests you, whether it is a building, the light on a group of trees, or the pattern formed by fields and crops. Think about the effect of the light, because cloud shadow can help to concentrate attention on the main area of interest. It can also provide a pattern, or break up big areas of green fields. If there are large areas of a similar colour, look hard for any other colours that are in there and accentuate them slightly.

In an open landscape, look for a changing or undulating horizon. Avoid a straight line across the canvas unless the terrain is very flat. Always try to relieve an unbroken horizon or skyline with vertical elements.

Look for features such as roads, hedges, fences, walls and even ditches and furrows that run through the scene, because you can use them to lead the eye through the picture and link different areas of the composition. Avoid panoramic landscapes that have no prominent features because the eye will meander all over it without settling anywhere. And if the composition is based on a pattern it must be obvious.

FROSTY FIELDS, ASTON (25 x 35 cm/10 x 14 in)
The general atmosphere was that of a cold, frosty morning. There were many warm colours due to the quite strong sunlight, and there was a strong atmospheric haze over the hills as the sun came up. The road snakes through the landscape and up to the buildings in the mid-distance, the secondary area of interest. From there the implied ditch line and hedge lead back down to the buildings in the foreground.

The sunlit sides of the trees have been painted with very soft edges, and on the hill some colours are just suggested. Colours are soft and blended throughout the painting to suggest the hazy atmosphere. Buildings in the distance have been identified only by the light areas picking up the sun.

Each section of the road shows the effects of perspective as it moves into the distance. Where the road runs horizontally across the canvas, it becomes a narrow strip because it is seen from the side. When it turns away it widens again, but to a lesser extent as it recedes into the distance.

AUGUST, OVERLOOKING SACOMBE (60 x 75 cm/24 x 30 in)
The eye is led into the picture by the road and the figure walking down the hill. The feeling of the road running down into a hollow has been created by the dipping line of trees, with the foliage of the further trees extending down to ground level. Cloud shadows create a linking feature throughout the painting, and the clouds echo the round shapes of the trees.

SILENT SNOWSCAPE
(25 x 35 cm/10 x 14 in)
A fine veil of snow in the air muted all the colours, which as a result are very subtle. If you compare the snow colour to a white sheet of paper, or even to the sky tone, you will see how dark the snow has been painted and that positive colours have been used in it. In places a warm underpainting shows through the snow to suggest warm areas of colour created by the undergrowth.

Practice

Trees provide an endless source of interest for
sketching and painting in their own right as well as
being important elements in a landscape. When you
are studying trees, try to see big foliage shapes
within a tree; the way that branches are joined to the
trunk and whether they are spaced regularly or
irregularly up the trunk; and whether there is a main
direction of growth.

*In these examples, the trees have been treated as flat shapes,
and they illustrate the varying characteristics of different
species. Copy these, and make similar sketches from nature to
find different ways of interpreting trees.*

EVENING BY THE RIVER AT KINGSTON
(17 x 25 cm/7 x 10 in)
*Right, small clusters of leaves were picking up the evening light
against a dark background. They were painted quickly with
flicks and dabs of paint, using a small brush and the tip of the
palette knife. The tunk has beeb painted with a series of
downward, quite broad brushstrokes.*

*Make a study from this painting, concentrating on the tree,
and try to copy the foliage and trunk mark for mark to
analyse the way the paint has been applied.*

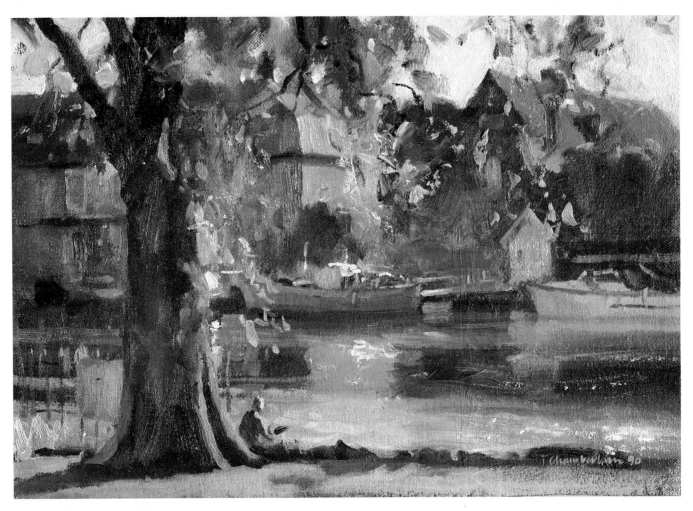

WINTER MORNING, RIVER MIMRAM

(40 x 50 cm/16 x 20 in)

This is a good example of how to treat groups of bare trees in winter. The trees were blocked in with the side of the brush over the underpainting, but were also indicated in the underpainting. The lines of trunks and a few branches were then put in more carefully. Branches growing in different directions add interest.

The foreground has a warm underpainting. A dry brush was used to put in the reeds and grasses, and a palette knife was used to put in the highlights.

Buildings and Street Scenes

The best way to approach buildings is to see them as boxes, but be aware of their textures, colours and details. Buildings are more easily defined as solid objects when they are seen in sunlight, which renders some walls in shadow and also creates cast shadows. Any embellishments or decoration should be added where necessary, but not in detail. You need to be selective about this. Details and contours are picked out in sharp relief in sunlight, whereas they should only be hinted at in shadow areas. In *Entrance to Clink Wharf* (page 42) the building in the centre is lit by top lighting, and the light is filtering down between the buildings around it. The light

catches the ledges and projections, and emphasizes the relief effect of the surface. The details were painted with a palette knife and the chunky effect suits the subject.

You need to draw the structure carefully, because buildings must look convincing. Check the proportions: what is the height in relation to the width?; what is the angle of the roof?; how much of the roof can you see and what shape is it?

In *Morning, New River at Ware* (page 69) the light is on the roofs of the cottages, and the shadows from the chimney stacks cut across it. The walls of the buildings are in shadow and pick out the shape of the lit roof. The building beyond the cottages is seen in silhouette, and the glint of light on the roof is not so light in tone as those in the foreground.

Think about the movement of the sun during the time you will be working, because this will drastically alter the lighting effect. If shadows will move, put them in where you want them and then ignore any subsequent changes. Look for the effects of reflected light, because the dark flank of a building seen running away from you will be picking up reflected light from the things around it.

DECEMBER MORNING, CRIB STREET
(25 x 35 cm/10 x 14 in)
This was painted on a very bright morning with the long cast shadows typical of winter. There was a wide range of colours and tones in the scene due to the bright sun, creating a strong contrast between the light, warm side of the street and the dark, cool side. The different faces of the buildings have been treated as simple shapes, with a cast shadow breaking up the big shape of the building on the left and unifying the scene. A variety of interesting shapes were seen in the roofs, and a few figures have been sketched in to give the scene life.

ICE-CREAM VENDOR, NEW YORK (20 x 15 cm/8 x 6 in)
Right, the whole scene has been reduced to the bare essentials, to create the effect of a road running through a chasm with towering buildings on either side. The buildings have been treated as large slabs of colour with one or two patches of sunlight breaking up the surfaces. The people provide a sense of scale, and break up the areas of light and shadow on the road. The accent falls on the colourful umbrella against the dark road beyond.

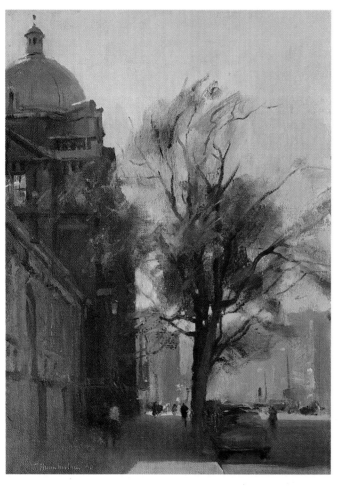

PERSPECTIVE

In order to make buildings sit squarely on the ground it is necessary to understand a little bit about linear perspective, because parallel lines seen receding into the distance appear to converge at the horizon. However, it is not always possible to see the horizon, and it is usually more practical to relate buildings to your eye level, which you can establish by holding up a pencil horizontally in front of your eyes and noting where it cuts across the scene. You can draw it in on the canvas when you are sketching in the composition initially if this helps.

WINTER AFTERNOON, ALBANY STREET (17 x 25 cm/7 x 10 in)
Below, the terrace on the left has been treated as one unit. The features that define its character, such as the balustrade, have been picked out but treated very simply. The windows have been put in with simple downward strokes that peter out at the bottom where they catch more light. And they fade out beyond the first two or three houses. The chimney-stacks have been quite roughly stated.

Although it was winter, the scene has a warm overall glow because a lot of warm light was bouncing off the stucco buildings. The buildings in the distance were catching the light, but have been treated broadly with a single palette-knife stroke over the underpainting after the distant trees were put in.

IN THE SHADOW OF THE V&A (35 x 25 cm/14 x 10 in)
Above, because the building was in shadow, it was interesting for its overall shape rather than its architectural features. The tones in the dome have been graduated to create roundness, with a highlight on the top edge, then a darker area, and reflected light around the base. The areas of light and shadow across the road have also been treated as large simple shapes, but are broken up by the figures moving from shadow into sunlight.

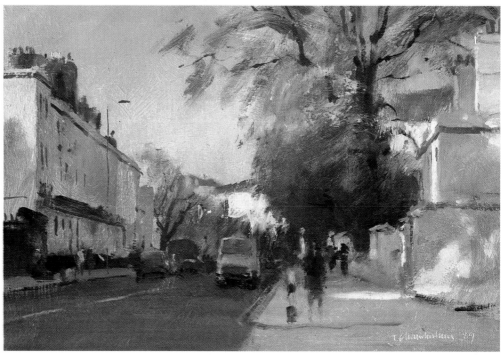

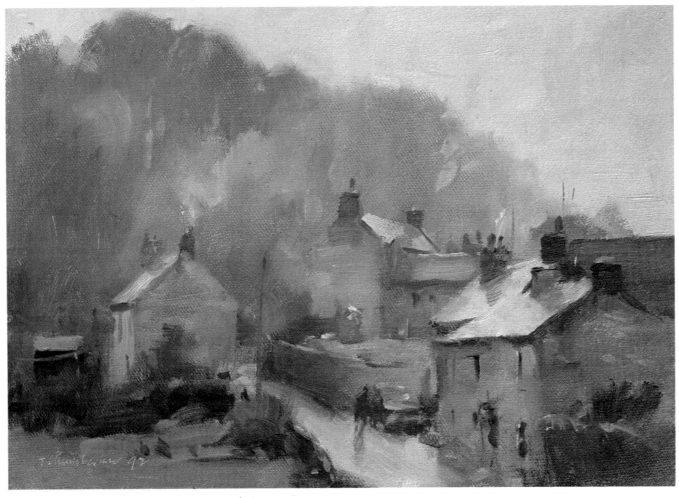

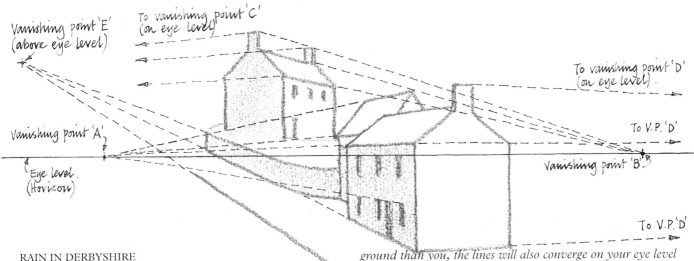

RAIN IN DERBYSHIRE
(17 x 25 cm/7 x 10 in)

All buildings are constructed on level ground even if the ground around them is on an incline. If you and the building are on level ground, the converging lines will meet on your eye level – vanishing points A and B. If a building is on lower or higher ground than you, the lines will also converge on your eye level – A and D, and B and C, respectively. This applies whatever the angle of the building to your position. If a surface such as a road is sloping uphill, the sides of the road will converge above your eye level – E; if downhill, the sides will converge below your eye level.

OBSOLETE SIGNAL-BOX,
KINGS CROSS
(25 x 35 cm/10 x 14 in)
The signal-box is the main feature, with light coming from the front left and catching its side. A cast shadow from a building out of the picture to the left is cutting across the bottom half of the signal-box and through the diesel smoke. The railway lines are merely indicated with a few darks and relevant highlights here and there. Silhouettes create interesting shapes along the straight line of the roof ridge. The station and other buildings have been played down so as not to distract attention from the signal-box itself.

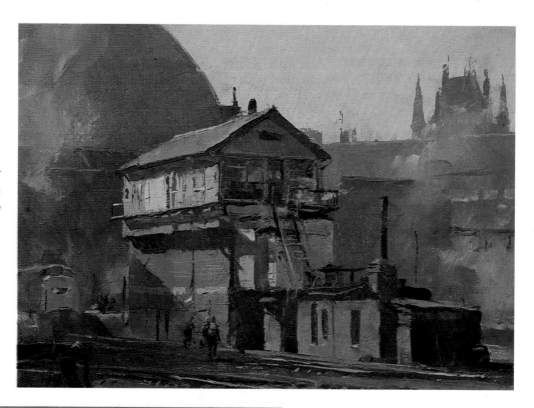

THE RED UMBRELLA
(25 x 17 cm/10 x 7 in)
Right, don't let the rain stop you painting - this was done in the pouring rain, under the shelter of a cornice. All the colours were very subdued because of the rain. The buildings have been treated as simple shapes, with suggestions of details such as windows, chimneys and signs. The building at the far end is lighter than the rest because it is reflecting light from the sky.

SPRING, WELWYN GARDEN CITY
(17 x 25 cm/7 x 10 in)
Quite acid oranges, blues and greens together with strong blue shadows have been used to capture the atmosphere of a bright, sunny spring day. The objects in shadow, such as the dark car under the trees, have only been hinted at. Hedges and lawns have been broadly stated with directional brushmarks. There is a feeling of activity although the people have not been clearly defined.

DETAILS

It is important to get the proportions of doors and windows right in relation to the building. Look for reflections in windows. Higher windows are lighter than lower ones, unless they are open, because they are reflecting more light from the sky. Where windows are seen straight on, don't paint in all the glazing bars, just suggest them here and there. And notice the way in which the top of the window reveal casts a strong shadow across the window and the frame at the top, but a lighter one at the bottom.

Don't get bogged down in painting features like balustrading and chimney-pots. Again, rough them in, and leave out some chimneys if they detract from the overall scene. Brickwork can be suggested with directional marks in the underpainting.

In a street scene, cars and people give a feeling of life and activity, but they should be kept simple. If they are in shadow, just give a hint of the forms.

RAINY DAYS

On a wet day, surfaces such as streets have reflections, but these are less obvious than on a river or pond. Because the water surface is superficial, the road or pavement surface breaks it up. It is important to suggest the road surface showing through or people will look as if they are walking on water - see *The Red Umbrella* (page 98).

In *Rain in the Air, Notts* (page 36) there is a large puddle with simple reflections. Normally, the sky would be lighter than any reflections of it. Here, however, the reflection in the puddle looks lighter than the sky because it is surrounded by surfaces that are darker than the things next to the sky itself. This can only be observed by a very careful assessment of the relative tonal values in a scene.

STATUES

When painting statues, the amount of detail you include should be guided by the light falling on them. Compare *Passing By, Greenwich* (page 101) with *Summer, Albert Memorial* (page 42), which are lit from different angles. In the former, the statue was in shadow and has been treated in silhouette with very little detail. The Albert Memorial was lit from one side, picking up rich colours and some of the architectural details, so an indication of these has been put in.

MORNING AIR, WEST PIER,
BRIGHTON

(60 x 90 cm/24 x 36 in)

*Left, the architecture of this pier is very
distinctive. The left-hand building has
a wedding-cake look about it, and its
character has been captured with a
minimum of detail. The right-hand
building has structure, but it has been
stated less strongly. For example, the
darks are less dark than those in the
nearer building. And because it is
further away aerial perspective is at
work, muting the colours. Because the
horizon was visible, the perspective was
quite straightforward.*

PASSING BY, GREENWICH

(20 x 15 cm/8 x 6 in)

*This statue is seen in silhouette, but
even though it is in shadow, quite a lot
of the moulding has been included. The
darkest shadow accents were put on last
with a sable brush.*

TATE GALLERY

(25 x 35 cm/10 x 14 in)

*When painting classical architecture, it
is particularly important to get the
proportions right, and to give a correct
indication of decoration, embellishments
and detail, but they should still be
treated as broadly as possible. You
should also pay attention to the
materials used in the building. In this
case it was stone, which weathers,
changes colour, and becomes streaked
and stained from the effects of rain and
pollution.*

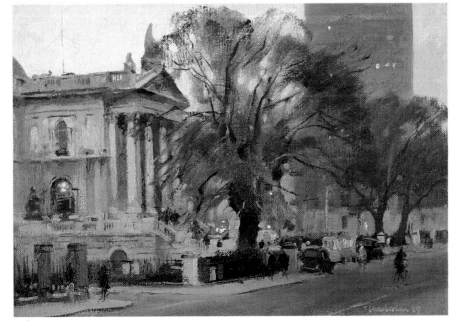

Practice

Light falling on a building defines its shape and gives it volume. The angle of the light at different times of the day has a dramatic effect on the way a building is seen. The colours and tones seen in buildings are strongly influenced by the things around them, and it is important to look hard for the effects of reflected light as it is often present even in quite dark areas of shadow.

Study the three examples on the opposite page of a building at different times of the day, and make copies. Then find your own examples to study.

Evening street scenes provide a good opportunity to study the combined effect of natural and artificial light, which is a fascinating subject in itself. In particular, the light from windows glows strongly against deep, cool evening shadows.

LIGHTING-UP TIME, ST LEONARD'S TERRACE
(15 x 20 cm/6 x 8 in)
This provides a good study of natural and artificial light. The buildings on the left were still receiving the afterglow of the setting sun, and the roofs and chimneys were picking up warm light. The cold, blue side of the building on the right was facing away from the light, but the others on that side were also picking up some warm light from the sky. The right-hand buildings were in partial shadow, and the warm artificial light from the windows glowed against this.

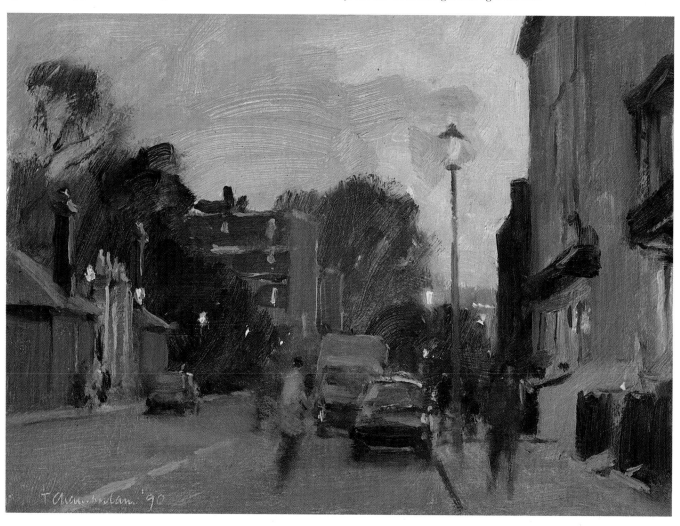

MORNING

(15 x 20 cm/6 x 8 in)

The sun was coming from the front left. The shadows cast by the chimney-stack and the porch are hard-edged because they are close to the objects casting them. The colours are muted because it was early morning. The shadow across the front of the house was fairly cool because it was picking up the sky colour.

The darker face of the porch was warmer in colour, and lighter in tone, because it was picking up warm light reflected off the lit front face of the building. The end wall was not so warm as the shadow face of the porch because it was not picking up warm reflected light.

EARLY AFTERNOON

(15 x 20 cm/6 x 8 in)

The sun was high in the sky, so all the faces of the building were in shadow, but were being influenced by other things. The main face of the building and the end of the porch were cooler and lighter than the others, and the whole building was deeper in tone compared to the light on the roof. The chimney stack and its shadow were the darkest part of the picture. The roof was reflecting a lot of light, but still contained positive colours. Compare it to a sheet of white paper to see this better.

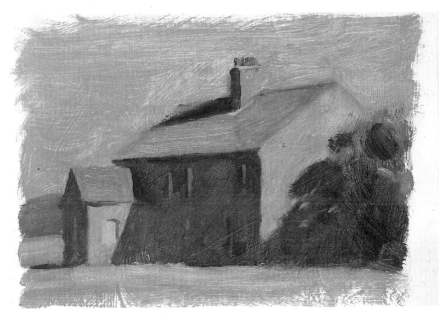

EVENING

(15 x 20 cm/6 x 8 in)

The light was coming from the right and different faces of the building were lit. The main face was still in shadow, but was then picking up warm light from the side of the porch, part of which was in sunshine. A cool dark shadow cut across the side of the porch. A shadow was being cast by the bush across the end face of the building.

Interiors

The main differences between interior and exterior scenes are the proximity of the subject and the nature of the light. If you are painting a rather dark interior, you need to position yourself so that you have light on your canvas and palette.

When you are working indoors you are often much closer to the subject than when out of doors, and you have a much stronger sense of the subject surrounding you. In certain cases, you may in effect be painting a vast and complex still life. It is more important than ever to simplify the subject, and to be very selective about what you include in order to give emphasis where you want it in the painting. If the scene includes a lot of clutter on a table or window-sill, select those elements that stand out as strong shapes and play down the rest.

Indoors there can be several light sources, and you need to note where they are, and whether they are natural or artificial, and therefore casting a cool or warm light. There will often be a mixture of the two, although there is usually little influence from the sky, except through a window. In interiors, natural lighting appears cool and shadows warm, which is the reverse of out of doors. In interiors, patches or shafts of light can be used in the same way as shadows out of doors to define the shape of things and to link elements throughout the composition.

Light is very important for creating a sense of space, as can be seen in *After Lunch, Chelsea Hospital* (page 107), where the reflected light on the left-hand wall is an important part of the picture. The rules of linear perspective apply in the same way as out of doors. You should begin by establishing the eye level (see page 96), and relate your surroundings to that. There is little aerial perspective in interior scenes unless the room is smoky or steamy, as in *Interior, Venice Fish Market* (page 107). Mirrors can also imply space, because they suggest something beyond the scene being painted.

WINDOWS

Although you can see a lot of detail through a window, you need to make it recede into the distance by simplifying the shapes and toning down the colours and contrasts.

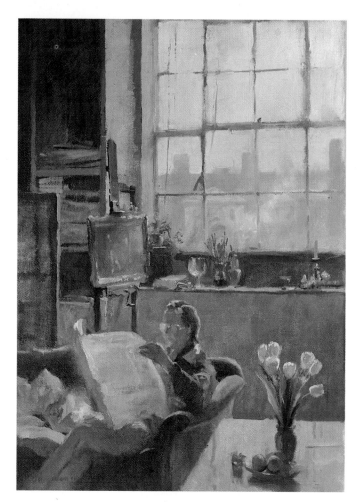

JULIAN AT 33 TITE STREET (50 x 35 cm/20 x 14 in)
*Above left, this was a typical old Chelsea studio of the type
used by many renowned artists. The window faced north-east
and was very large; less than half can be seen here. The cool
light from the window reflected off and influenced everything
in the room. Highlights occurred on the easel, the window-sill
and frame and the figure's forehead, while light bounced off
the newspaper onto his face and spectacles. The objects on the
window-sill such as the flowers were seen against the light and
were therefore treated in outline. Everything through the
window has been played down. The bars in the window were
indicated in the underpainting, and the scene through the
window was then painted up to them.*

SWEET ROCKET AND PEONIES (35 x 25 cm/14 x 10 in)
*Left, the flowers had a pink underpainting, and the light and
dark areas within the whole group were indicated, the darkest
part being the peonies against the light patch of wall behind and
the refracted light in the bowl. The general shape and colour of
the two kinds of flowers have been indicated, with a little detail
here and there to suggest their individual characteristics.
Directional marks have been used to hint at a few petals.*

*The window reflected in the mirror gives a strong suggestion
of a world outside the immediate scene. The scene through the
window has been reduced to simple, light-coloured areas with
an impression of foliage in the bottom left-hand corner.*

AT THE FORGE WORKBENCH (25 x 35 cm/10 x 14 in)
*The window was a very strong feature due to the sunlight
coming through on to the workbench, outlining the top of the
vice and the profile of the figure. The light also picks out bits
and pieces among the paraphernalia on the bench itself, but only
the white jug and the tin on the right, which form strong
features, have been indicated. The light on the bench was
emphasized because it contrasted with the dark corner behind it.*

*The background had a warm overall underpainting of
burnt sienna and yellow ochre and some ultramarine. More
accurate final colours were scumbled over the top,
concentrating on capturing the light background against the
man's dark shoulder and the area of wall behind him that was
picking up cool light from the window. The dark shapes of the
harness were indicated with a brush but not overstated.*

*No attempt has been made to paint a portrait. The man's
features can't be seen except for the cool light on his cheek and
chin picked up from the sweater. Contrasts have been created
between the man's light cap and the dark wall behind, and
between the light side of the vice and the dark background,
creating a sense of space between foreground and background.
Lights and darks were emphasized to create these contrasts.*

*Reflected light on the man's back, the back of his arm, the
front face of the workbench, the side of the jug and the
underside of the window-sill, comes from the sunlit patch on
the workbench and helps to unify the different elements.*

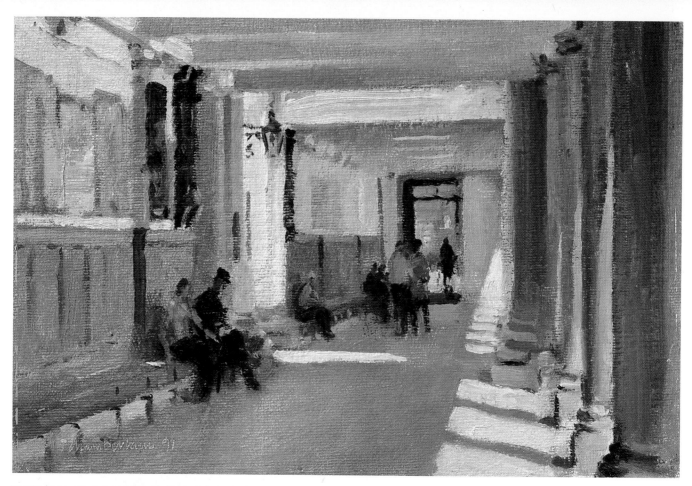

TEA-TIME, HARROGATE ASSEMBLY ROOMS
(25 x 17 cm/10 x 7 in)

This ornate, classical interior was simplified in order to concentrate on the fundamentals. The colour of the walls was very warm, and the carpet was a strong colour, set off by the hints of cool colours from outside seen through the doors and windows, and the cool colours of clothing. The light was coming from the left, and pools of light fell on the carpet, altering the colour considerably. The figures gave scale and life to the scene, but were indicated just with smudges of colour. The chairs and tables were simplified to give emphasis to the carpet, and were grouped together to improve the composition.

The ornate details around the tops of the columns have been suggested accurately, but are played down.

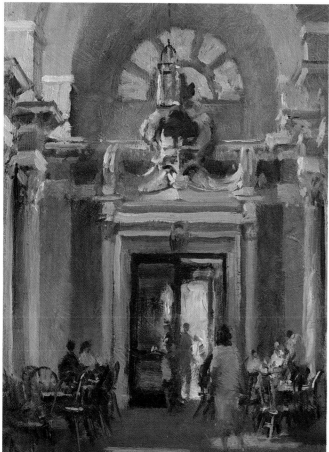

AFTER LUNCH, CHELSEA HOSPITAL

(17 x 25 cm/7 x 10 in)

Left, this painting is fairly high toned, and very subtle warm colours have been used. The reflected light down the left-hand side is very important in creating a sense of space in the picture. This provides a good example of linear perspective in an interior. Notice also that all the heads of the figures are on the same level (see page 96).

INTERIOR, VENICE FISH MARKET

(25 x 17 cm/10 x 7 in)

This was a scene with a lot of bustle and activity, and the warmth and colour inside contrasted with the cool light outside, seen through the arch. The wet floor was reflecting light through the archway; further into the building the reflection grew weaker. The structure of the building was suggested with directional marks, supporting the main centre of interest on the floor. It is important to get the structure and proportions of a building right, however loosely it is painted.

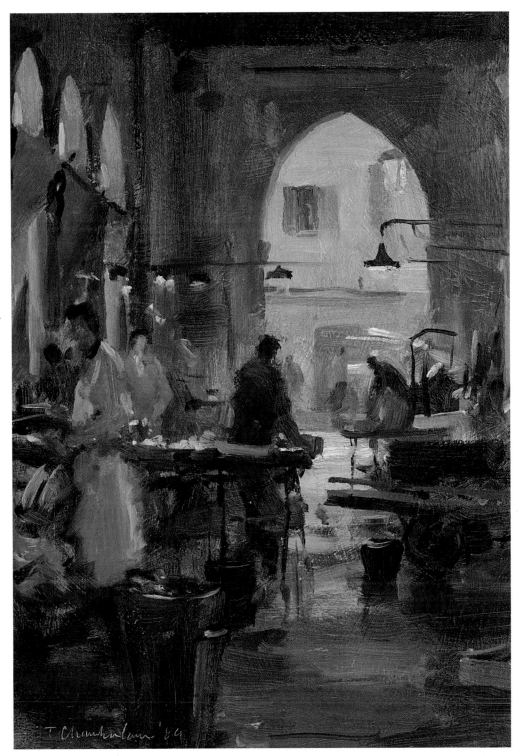

Shadows

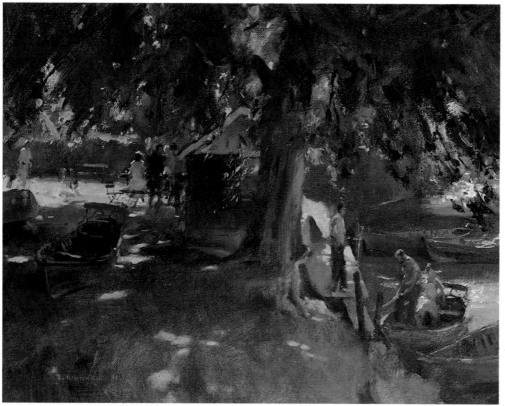

SUMMER ON THE STOUR, DEDHAM
(40 x 50 cm/16 x 20 in)

The large tree in the foreground was very dense and only small chinks of light shone through the foliage. The shadow under the centre of the tree was very dark. Moving away from this area back towards the figures and tables, it became lighter and began to pick up cool colour from the sky. Moving forwards, the shadow came out of the influence of the tree into the open air. The shadow has been created mainly in the underpainting, using large brush marks to create texture.

The two boats in the foreground were in shadow but were picking up reflected light.

The people in sunlight had light on their shoulders and heads, and their legs were picking up light reflected from the ground.

The dark side of the foliage was lit around the edges, and light can be seen through it. A variety of greens, burnt sienna and darks were worked into the foliage. The colours in the foliage were worked into each other while the paint was wet so that they mixed slightly on

the canvas. The light foliage was seen against the dark shadow in the boathouse, and the dark foliage against the light on the river.

FELLED TREES, WATERFORD MARSH
(25 x 35 cm/10 x 14 in)

Right, a zig-zag pattern leads back to the fire; working against this are cast shadows across the ground, which follow the contours of the felled trees and describe their shape. Perspective can be seen in the shadows, which converge as they recede.

The shadow colours and tones change, and all the shadows are soft-edged, except where one trunk has fallen across another. Here the shadow is hard-edged and dark because it is being cast by something very close. The tops of the trunks are picking up sky colour, and on the undersides they are slightly darker, but there are patches of reflected light being picked up from sunlight on the grass. This has been painted mainly with a brush. The distant trees were scumbled over the underpainting and softened slightly.

Shadows help to define the shape and contours of objects that they fall across, as can be seen very clearly in *Felled Trees, Waterford Marsh* (above). In *Fred's Fleet* (page 70) cast shadows from objects outside the picture area fall across the boats and help to convey the shape of the hulls. In *Cow Parsley, Goldings* (page 86) the shadows follow the contours of the road and verges, with appropriate changes in colour.

Everything is seen in light, however subdued, and therefore all objects have a light and a dark side to them. The shadow side picks up colours and reflected light from the things around. The colours in shadows are therefore influenced by what is round about and are not just dark versions of the local colour. They have their own colour.

Out of doors, a lot of things in shadow are influenced by the sky colour or the condition of the sky. Shadows in the distance are subject to the same influences and become more muted. Immediate foreground shadows are stronger and several colours can be seen in them. In *Morning Air, West Pier, Brighton* (page 101), the shadows under the pier in the foreground are quite dark and warm in colour, but where the shadow emerges into the area beyond the pier, it is picking up sky colour and becomes

This was painted looking towards the sun, and the sun was quite high and casting strong shadows. The full intensity of the light was trapped at the bottom of the alleyway, and bounced up and dispersed around the walls, especially the right-hand wall, which was in shadow but strongly influenced by reflected light. The shadows on the ground were much cooler in comparison, and contrasted with the lit ground.

The figure was in full sunlight, with light on the head and shoulders and reflected light from the ground on the legs. The foliage was brushed in quickly, and accents of light were quickly stated with the brush and knife. Burnt sienna, yellow ochre and muted blues were used in the shadow on the right-hand wall, which was done in the underpainting and then left. Directional marks have been used to indicate the brick courses, with stronger marks for the windows.

lighter and cooler. The shadow was also affected by the movement of the surface of the water. Shadows are also subject to linear perspective in that they converge towards the eye-line (see page 96), and narrow as they recede.

Cast shadows can contribute to the composition by linking up different areas in the painting. In *June Morning, Budleigh Salterton* (page 21) the cloud shadow was used to make a dramatic feature of the high part of the cliff, and to create a contrast with the warm beach. The shadow continues down the beach, describing the slope of the beach, and out across the sea. It extends across the hill in the other direction, forming a silhouette, creating one continuous linking shape. The shadow has many different colours worked into it.

When played against light areas, shadows form strong contrasts, and you should always be looking for darker objects against a light background and lighter objects against a darker background.

PAINTING SHADOWS

Use broken colour in shadows, that is, specks of individual colours, rather than mixing one overall colour. The colours placed in juxtaposition to each other will vibrate and prevent the shadow area from becoming one dark, uninteresting shape. Most shadow areas can be dealt with in the underpainting. For example, in *Corner of Ponsonby Place* (page 28) the shadow area under the trees has been treated as one simple shape with loose, directional marks. In *Cow Parsley, Goldings* (page 86) variation in the colour of the shadow areas was achieved by loosely mixing the colours in the underpainting.

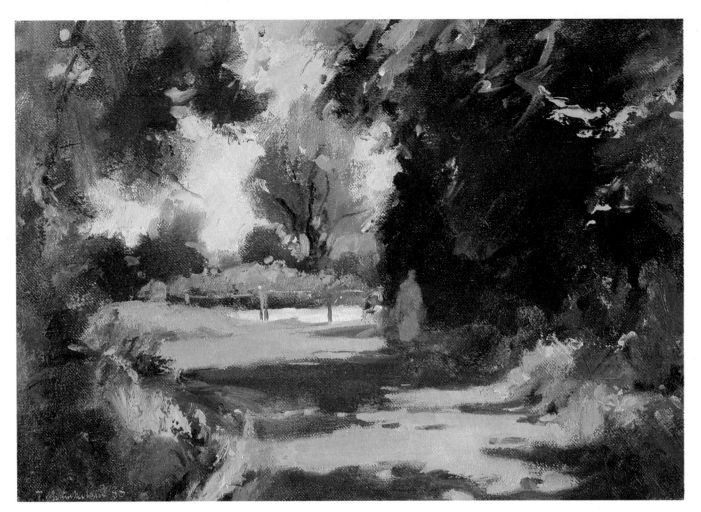

SPRING DAY, CHAPMORE END
(25 x 35 cm/10 x 14 in)
This was painted on a bright spring day. A lot of bright colours were used in the underpainting. They did not reflect the scene accurately, but they give vibrancy to the colours that went on top. For example, the dark area of foliage on the right of the figure has been painted with a mixture of ultramarine and burnt umber over a very bright underpainting.

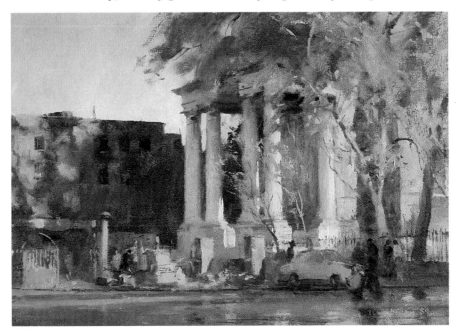

SPITALFIELDS, LONDON
(25 x 35 cm/10 x 14 in)
There was a warm wintry light emphasizing the light tones on the buildings. The shadow sides of the columns were picking up strong reflected light, suggesting roundness, and are set against the dark buildings beyond. The trees in the right-hand foreground are seen against the building. Some trunks are dark against a light background, others are light against a darker background. The foreground was in shadow, but because the surface of the road was damp it was picking up light from the sky.

People and Animals

People give a sense of scale, life and activity to a scene. If they are incidental to the main subject, they should be stated in simple terms without too much regard to features or details. Try to paint them with a minimum of brushstrokes, tending towards understatement rather than overstatement in the degree of finish.

Arrange people in interesting groups rather than stringing them out across the picture, and place the groups at different distances into the scene. To make people look convincing, it is more important to get the general bulk and stance right than to make the figures too detailed. If a person is moving, you need to concentrate on getting the weight and balance right. And people should be properly related in size to their surroundings.

When you are beginning, try to find someone who is likely to be there for a while, such as a fisherman, a person reading, or another artist. Alternatively, look for someone who is doing a repetitive activity, which will give you time to draw them. As with boats, you could do some sketches of people and use them to put people into a scene. However, it is best not to use a camera unless you want to record an action that is very complicated. In busy scenes such as markets and fairgrounds, although people are constantly on the move, groups tend to keep forming in the same places, giving you time to paint them.

If you are standing on flat ground, everyone standing on the same level will be on the same eye level as yourself, however far away they are, allowing for some variation in height. This can be seen in *After Lunch, Chelsea Hospital* (page 107) and *A Corner of the Whitsun Fair, Hertford* (page 113). This is very helpful, because when you are trying to sketch figures in quickly, you can concentrate on getting their feet in the right place in relation to their surroundings as you know where their heads will be. If you are on a lower level in relation to the people around you - for example, if you are sitting down - the closer figures will tower over you, and the heads of people in the background will be on a lower level than those in the foreground.

If you are working on the spot and do not have enough time to complete the painting there and then, sketch the figures in very rapidly with an indication of the tones and colours, and finish it at home. Try to work quickly when finishing off the painting so that you retain the feeling of spontaneity.

SWEEPING UP, SPITALFIELDS MARKET
(15 x 20 cm/6 x 8 in)
Left, even mundane activities such as this can provide interesting subjects. These figures have been treated as flat shapes. When copying this painting, rough in the figures in the underpainting, concentrating on getting the weight of the body in the right place in relation to the feet.

ROWING CLUB, RIVER LEA, CLAPTON
(15 x 20 cm/6 x 8 in)
The different groups and individual figures suggest a busy scene. Even foreground figures have been indicated quite roughly, so that they have a sense of movement. The foreground is quite plain, but the tyre marks lead in towards the nearest figure, and the oars on the ground lead in from the other corner.

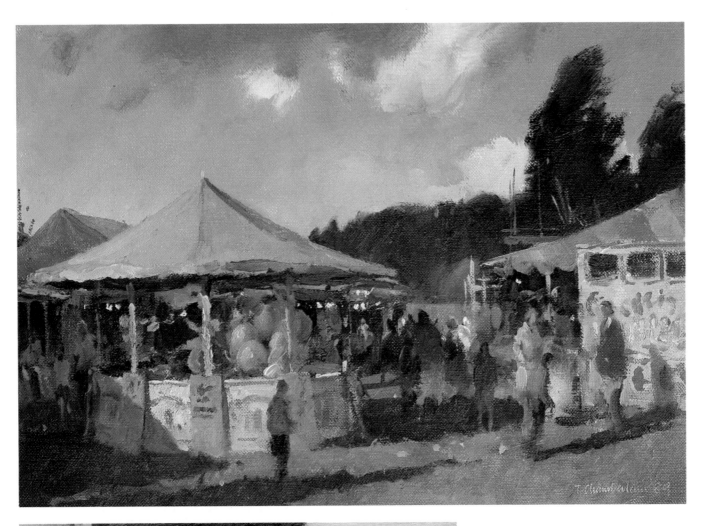

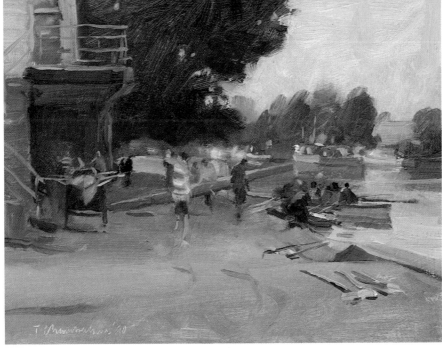

A CORNER OF THE WHITSUN FAIR,
HERTFORD
(25 x 35 cm/10 x 14 in)
Above, the figures were seen in and out of shadow and sunlight, and the groups have been arranged at various distances back into the scene. Most heads are on the same level, apart from the children. The groups were painted as groups, not as collections of separate figures, and touches of brighter colour and highlights were then added to distinguish between individuals. This scene was painted with brushes and a palette knife, and the colours and tones were slightly softened. A few dabs of paint have been used in the background to indicate figures on the move.

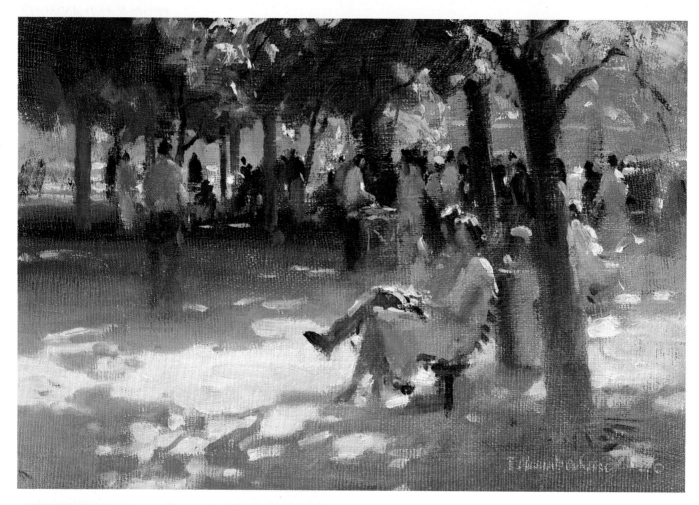

BOOKSTALL UNDER THE TREES, SOUTH BANK
(17 x 25 cm/7 x 10 in)
Although there were dozens of figures under the trees, they have been indicated quickly as one mass so that they all merge together. Their heads are roughly on the same level. The seated figures have been painted with more care as they were still.

The seated figures, left, have been interpreted as patches of light and shadow. On the far side of the further figure the edge has been lost completely. This creates the impression that that figure is behind the nearer one, which is a little more clearly defined. The fact that the shirt of the further figure has been painted in a warm colour next to a cool light area, and that the outlines are sharp where there are strong contrasts, separates these figures from the background.

OCTOBER, EDGE OF THE MEADS, HERTFORD
(15 x 20 cm/6 x 8 in)
Right, when painting sheep, avoid dotting the field with individual animals. Look for groupings and vary the positions that the animals are in. Leave some empty spaces between the groups, and in other places merge animals together. Half-close your eyes and look for the dark areas, warm patches of colour, and areas that are reflecting light. Sheep are not white, and this is especially apparent when they are seen against the snow. Look for a dusty yellow ochre and any reflected colour.

PAINTING PEOPLE
Roughly indicate people in the underpainting, concentrating on their shape and stance, and treat a group as one overall shape. Then suggest the parts that are catching the light to give them some form and distinguish them from their surroundings. Individual figures in the far distance can be put in with quick vertical flicks of paint, as has been done in *Edge of a Sandbank* (page 72). Some blurring around the edges of figures will help to create an impression of movement.

114

ANIMALS

Animals have a habit of wandering off, so paint some that are in a confined space. Although they will be moving around, if they are feeding they will keep adopting the same position, which gives you time to paint them.

Smaller animals such as sheep should be arranged in interesting groups. Try to vary their positions, and place them so that they are facing in different directions. You could also include one or two of another type or breed to add variety to the colours. If possible, position one or two animals on a lower level than the rest. For example, in *Windy Day on the River Beane* (page 61), one cow has been placed in the river, at a lower level than the rest, and two are of a different breed to break up the group.

With larger animals, look for reflected light on the cool side and on the underside where they will be picking up light from the ground. In *September, Waterford Marsh* (page 30) the horse in the foreground was light grey, but if you look at a horse in detail, you become aware of quite a lot of warm colours, especially on the underparts, whereas the top of the back picks up cool sky colours.

As with people, block in animals at an early stage, concentrating on getting the overall shape and stance correct. The positioning of the legs is vital in making animals look convincing. If you want to feature animals in your paintings, do some drawing work in order to get to know their anatomy.

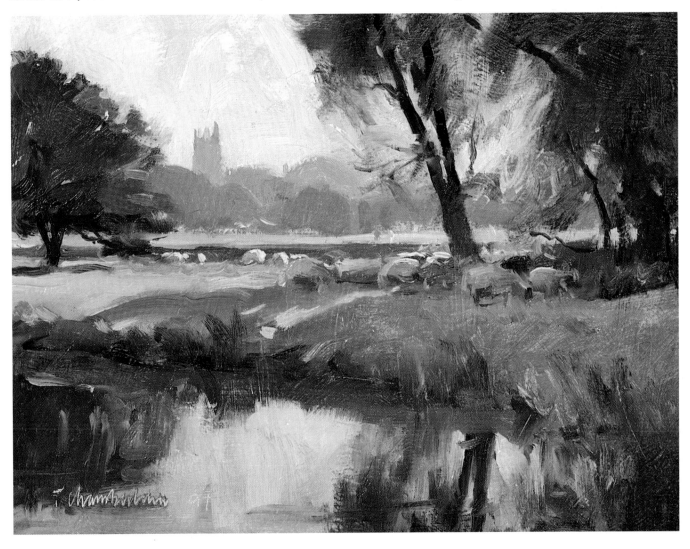

CATTLE, EARLY MORNING
(15 x 20 cm/6 x 8 in)
The cattle were painted while they were feeding and therefore they were fairly still. In the hazy, early morning light they were reduced to simple shapes, and subtle suggestions of modelling have been added here and there. The picture was done quickly because the shapes were simple, and the legs have been very lightly indicated so that they are left vague.

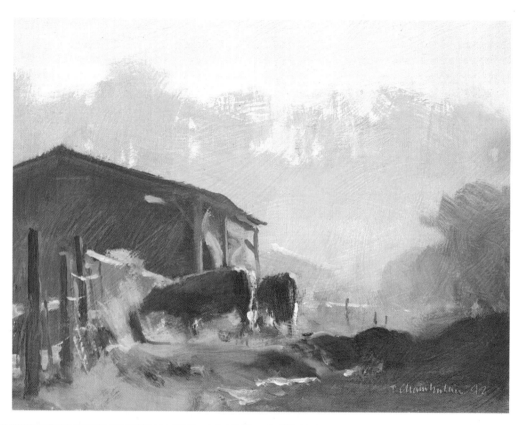

COCKERELS AND HENS
(15 x 20 cm/6 x 8 in)
The stances of the chickens have been varied. One cockerel is looking at the ground, and the hen is looking at another cockerel. There are indications of other chickens in the background. When painting any birds, it is important to concentrate on getting the shape of the body right and balancing it correctly over the legs. Do not get involved in trying to paint the plumage in any detail, but go for the overall colours and tones, and put in any reflected light that you can see on light-coloured birds.

Practice

Take every opportunity to sketch people involved in all kinds of activities, in pencil and paint. The sketches can be very rough. Do not worry about drawing heads, arms and legs correctly. You could even start by reducing the figures to directional lines. Look for the angle made by an imaginary line across the shoulders, and the position of the head, shoulders and hips in relation to the feet. Then put in the shape of the body. Study and copy the pictures here to see the way in which figures can be arranged into pleasing groups and can be suggested with the minimum of brushstrokes.

FIGURE SKETCHES
Top, this shows just how much can be indicated with dabs and smudges of paint. The different movements and positions of the figures are indicated through their overall shape.

TOBOGGANING, THE
MEADS, HERTFORD
(17 x 25 cm/7 x 10 in)
The figures in this scene have been arranged so that the larger, main group on the right is balanced by a smaller group on the left, and individual figures break up the line of the river. Copy this scene, studying the variety of different positions and stances of the figures. The figures in the field at the bottom of the hill have been indicated with smudges of colour.

Index

Acknowledgements

When Ron Ranson asked me to do this book, I was pleased to agree, knowing that I had in my studio a collection of paintings which I had gathered together in preparation for a One-man Show at the Oliver Swann Galleries in London in November 1992. In addition to this core of work I was able to borrow other oils from various collectors of my pictures, to whom I am grateful for allowing me the use of them.

I would also like to thank Helen Douglas-Cooper for transforming my ramblings into a readable text, Shona Wood (who shivered on site with me) and Clifford Borlase for fine photography, Jane Forster for visualizing and designing this book, keeping us all on schedule with such enthusiasm, and my wife, Elaine, for conjuring up meals and refreshments at odd times whenever required.

Trevor Chamberlain